W9-BMQ-112

EXTREME PHOTOGRAPHY

The hottest, coldest, fastest, slowest, nearest, farthest, brightest, darkest, largest, smallest, weirdest images in the universe...and how they were taken

RotoVision

A RotoVision Book
Published and distributed by RotoVision SA
Route Suisse 9
CH-1295 Mies
Switzerland

RotoVision SA
Sales, Editorial & Production Office
Sheridan House
112/116A Western Road
Hove
BN3 1DD, UK

Tel: +44 (0)1273 72 72 68
Fax: +44 (0)1273 72 72 69
Email: sales@rotovision.com
Web: www.rotovision.com

10 9 8 7 6 5 4 3 2 1

ISBN: 2-88046-760-8

Art direction by Luke Herriott
Design and cover design by Lucie Penn

Reprographics in Singapore by ProVision Pte. Ltd
Tel: +65 6334 7720
Fax: +65 6334 7721
Printing and binding in Singapore by ProVision Pte. Ltd

EXTREME PHOTOGRAPHY

The hottest, coldest, fastest, slowest, nearest, farthest, brightest, darkest, largest, smallest, weirdest images in the universe...and how they were taken

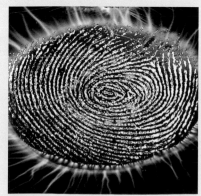 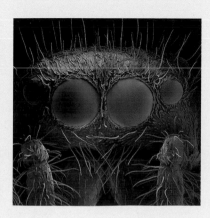 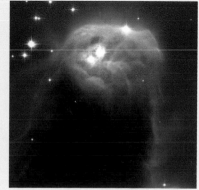

Terry Hope

contents

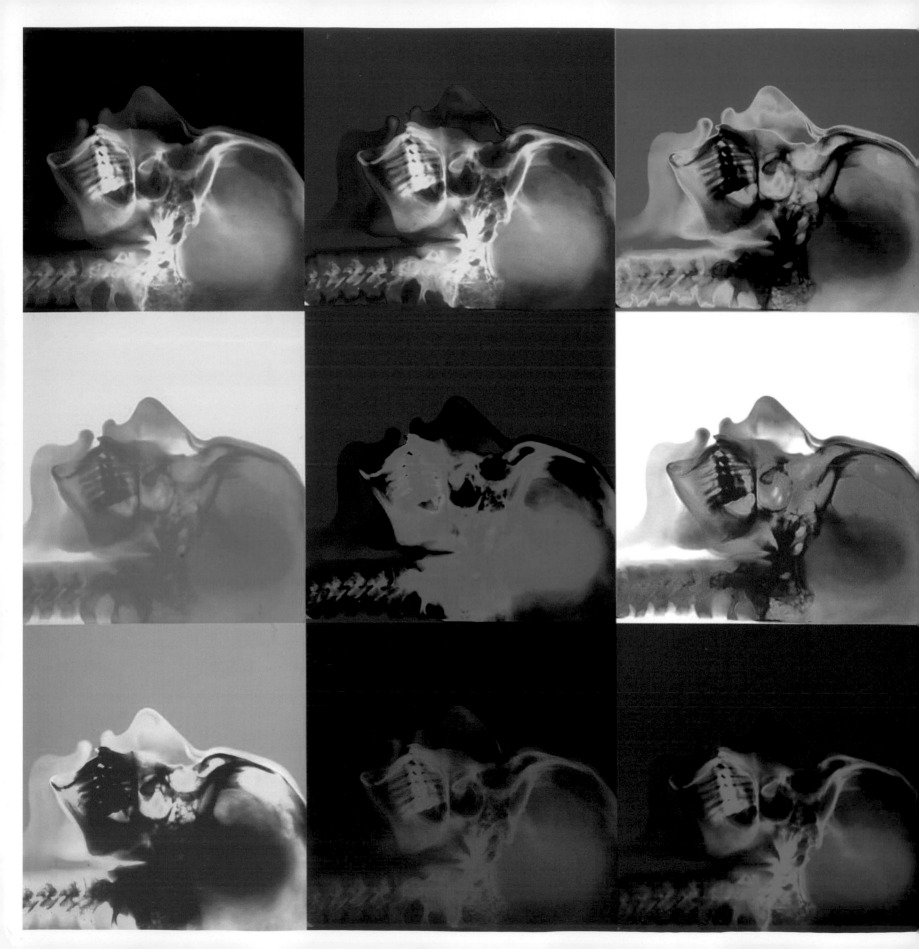

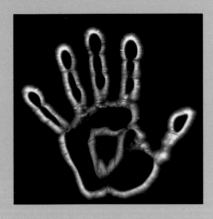

Introduction

Photography is about a lot more than simply pressing the shutter. Sometimes what is being recorded is impossible to approach in a conventional way; it may be too small, too large, too far away, too hot, too cold, or hidden away somewhere where the eye can't see.

Since the invention of photography all manner of breakthroughs have helped to open doors to new types of image. The development of X-rays, for example, allowed the camera to peer inside the human body. Later, the electronic scanning microscope made possible massive enlargements of the tiniest of subjects, to reveal the hidden secrets of flowers and insects.

This book takes these and other examples, and looks at what the extremes of photography really are. Focusing on cutting-edge technology, but also including historical examples, it shows the highs that photography can reach when it pushes at the boundaries of what is possible.

Just imagine the things that humankind would have missed out on had photography not been there to capture them. The pictures that have made us familiar with distant planets, as well as our own images of the human body made possible by ultrasound, endoscopes, and CT scans; the split-second incidents that cannot be perceived by the human eye are captured thanks to high-speed photography.

This book celebrates these achievements. The huge diversity of pictures shown and described here reveals a little of what has become possible with the invention of photography, and points toward the spectacular developments that may still lie ahead.

← **Facing opposite:**
Color X-ray montage of a human skull.
Shot by Peter Dazeley, this montage of digitally enhanced, high-color skulls is stunningly beautiful, but most importantly, shows up the incredible structure of the human head in compelling detail.

↑ **Top left:**
Detail of Kirlian image of a human hand.
The aura flares on this Kirlian image of a human hand reveal the balance of health and the emotional state of the subject. (Picture: Natasha Seery)

the hottest

→Lava junkies →Thermography

For photographers who use technology to reveal images that are normally not seen by the human eye, or who travel the world chasing active volcanoes, heat is the active ingredient that inspires some of the most dramatic pictures ever taken.

Lava Junkies

Most people would want to put as much distance as possible between themselves and an erupting volcano but, for a dedicated few, their sole aim in life is to head toward what is surely the finest display of natural pyrotechnics on the planet.

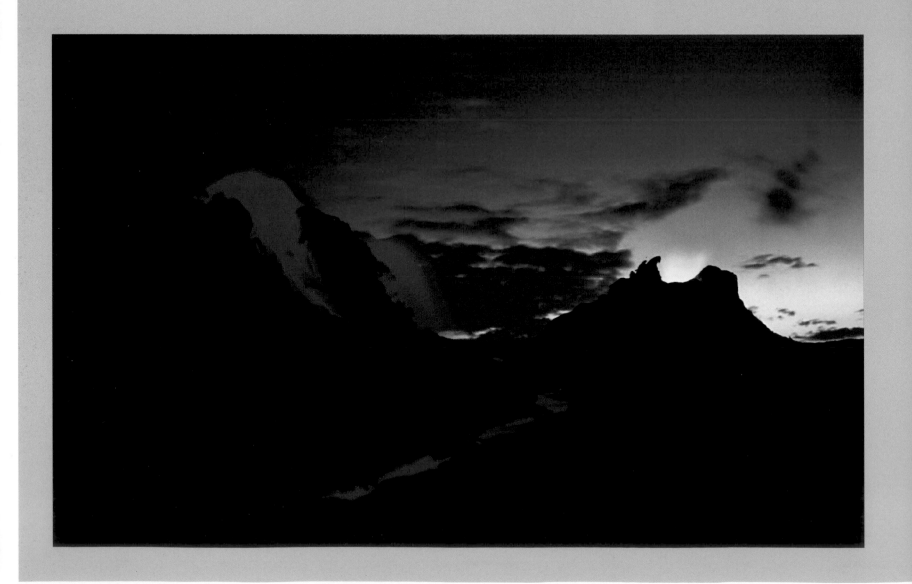

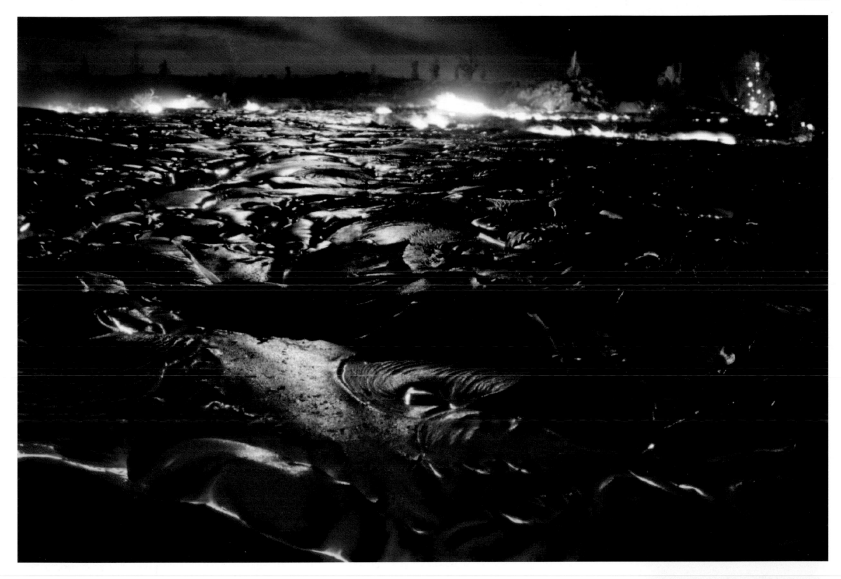

Jeffrey F. Brown

Adventurer Jeffrey F. Brown has photographed some of the world's most volatile volcanic sites, and his desire to experience the immediacy of volcanic activity has become his greatest motivation. Brown spent many years in Honolulu, Hawaii, where two of the world's most active, accessible volcanoes—Kilauea and Mauna Loa—are located and, while there, became inspired to record nature in the raw.

On his first visit to Kilauea, in 1998, Brown witnessed some awesome sights, including a lava fountain on the south side of the Puu Oo vent that reached nearly 50 feet (15 meters) in height. Since that time he has returned to Kilauea several times, and has also made visits to, among others, the Ol Doinyo Lengai volcano in Tanzania's Rift Valley, which has radically challenged his picture-taking—and survival—capabilities.

He uses a simple mechanical 35mm SLR camera which is reliable and robust in the most testing of conditions. Delicate electronic equipment would not be able to stand up to the gas, heat, and dust of the volcano environment. Exposures vary enormously,

↑ **Above:**
Kilauea, Hawaii
When this picture was taken, the lava flow at Kilauea was a quarter of a mile from the end of Chain of Craters Road, but later that same day it had moved swiftly across the road and into the ocean.

→ **Right:**
Kilauea, Hawaii
Stunning, dangerously close eruptions of molten lava, from this most active of volcanic regions.

← **Left:**
Ol Doinyo Lengai volcano, Tanzania
This is the volcano in Tanzania's Rift Valley, seen at night. A green flame is being emitted from the vent on the right, created by the burning of flammable gas.

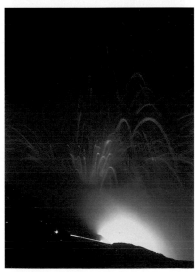

→ **Facing opposite, top:**
Lengai
The volcanic landscape at Lengai turns into an almost alien scene at night.

→ **Facing opposite, bottom left:**
Lengai
A dark lava fountain is seen against the vivid glow of an African sunrise at Lengai.

→ **Facing opposite, bottom right:**
Big Lion, Lengai
This is a six-minute exposure of the Big Lion vent at Lengai. Because the lava gives off such a dull glow, this exposure time is necessary to capture the full effect.

↓ **Below:**
Lava junkie
The classic picture of a lava junkie—the kind of person who is attracted by the danger and excitement presented by an eruption.

↓ **Right:**
Ol Doinyo Lengai volcano, Tanzania
This is the volcano in Tanzania's Rift Valley, seen at night.

but Brown uses a tripod to keep the camera steady when working at a shutter speed less than 1/60th of a second. "If I'm photographing something at night that features low light levels, such as the lava flows at Lengai (which are black during the day and glow a dull red at night), then I might open the shutter and give an exposure of a couple of minutes or more, just to allow the subject to register itself on film."

Living on the edge

No two days are the same in a volcanic environment, and potential dangers abound. Brown, in common with others who venture into these regions, carries a respirator to filter the air, which can contain sulfurous gases that are discharged from vents or lava tubes. Safety glasses are also needed to protect the eyes from shards of red-hot material. Good, solid footwear is another essential. Most seasoned volcano watchers have boots with thick, sewn-on soles, because the glued variety tend to melt.

Camping in volcanic regions can be very rewarding, because longer-term intimacy with the landscape encourages more spectacular pictures. The price to pay for this special relationship is the unexpected way in which threatening situations can develop. In 2002, Brown and his companions visited Ol Doinyo Lengai and witnessed the formation of a new vent, which sent torrents of lava to the west crater rim.

Despite moving their campsite, the group suffered an almost catastrophic incident. After three days of eruptions, a massive torrent of lava swept down the shield in the center of the crater, and the guides woke just as the lava was about to surround them. Reacting quickly, they cut a hole through the fabric, and escaped with mild burns. The following night they had a "lava watch" to preempt any further surprises.

"At Kilauea I've seen lava shot 200 feet (60 meters) in the air," says Brown, "and huge lava bombs thrown out into the sea. You have to be really careful not to stray, and you need to watch the ground you are walking on. Sometimes you come across shelly pahoehoe lava, which occurs near vents, and this is difficult to walk on because it features a thin crust. At other times the crust is thicker, but you can't stand still for long. The danger is that you might step or fall into molten lava: I did it once, and almost managed to fry some of my skin."

With a landscape such as this, volcano photography is not for the faint-hearted. Yet, for reasons that are evident here, lava junkies are on the increase.

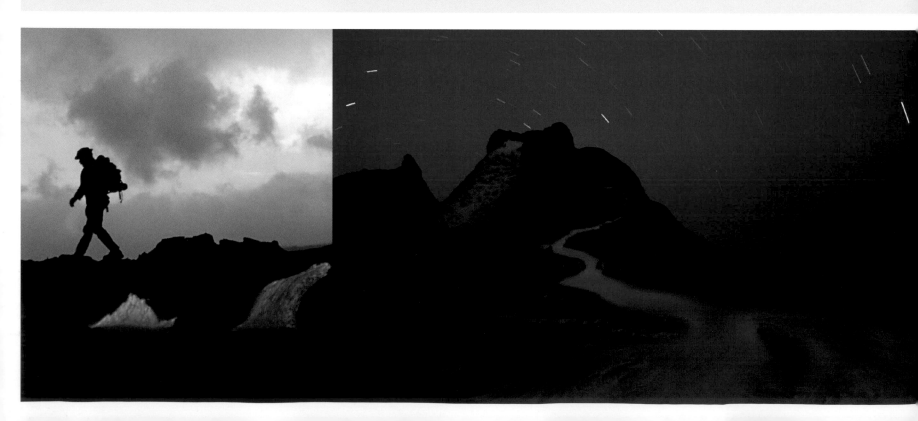

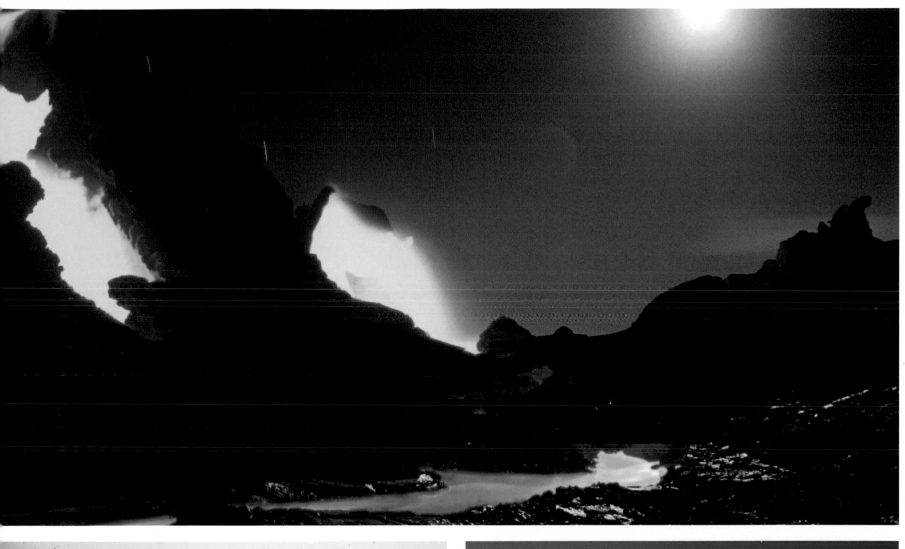

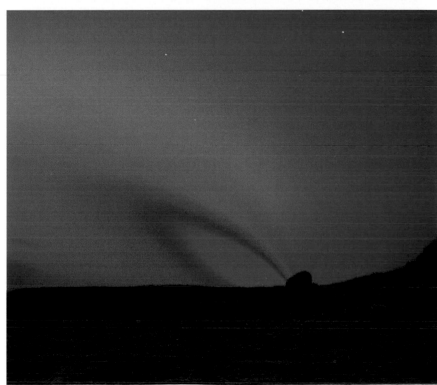

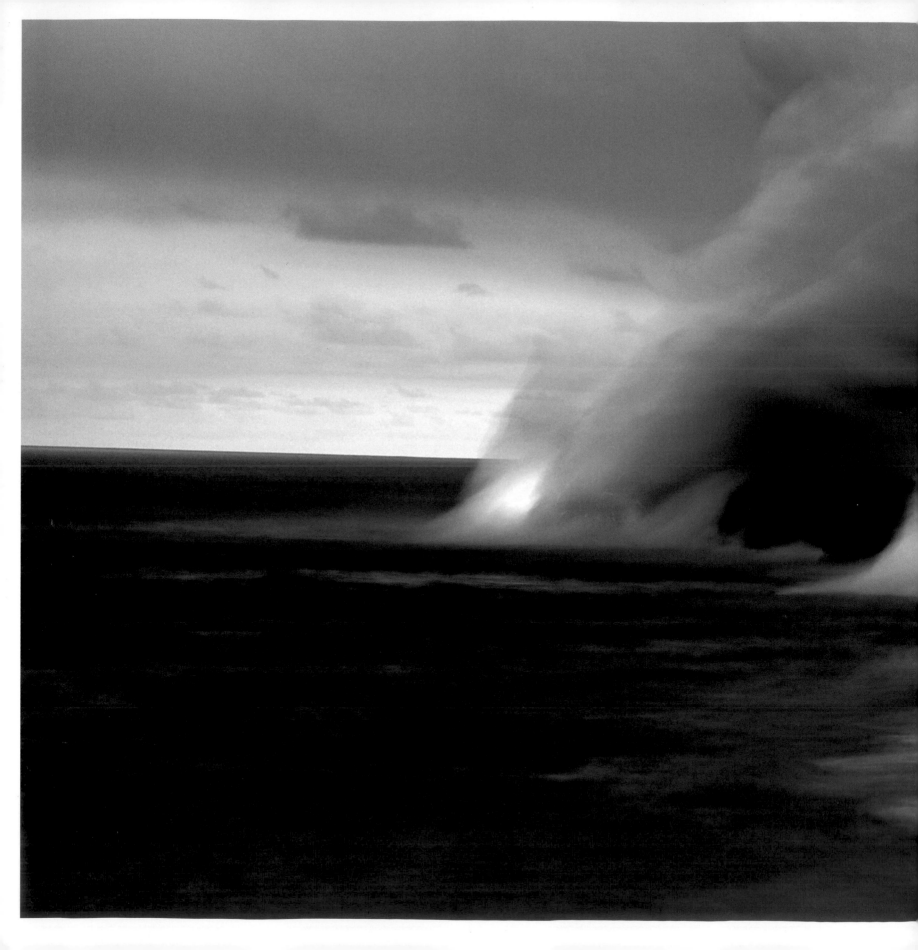

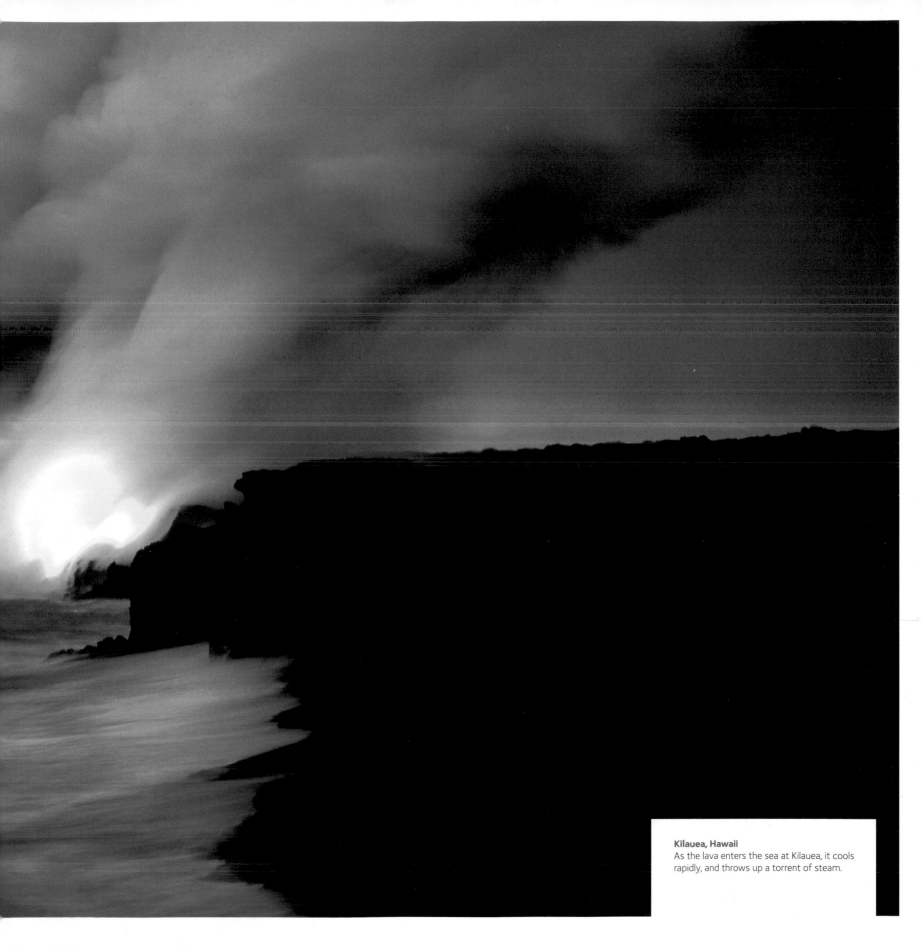

Kilauea, Hawaii
As the lava enters the sea at Kilauea, it cools rapidly, and throws up a torrent of steam.

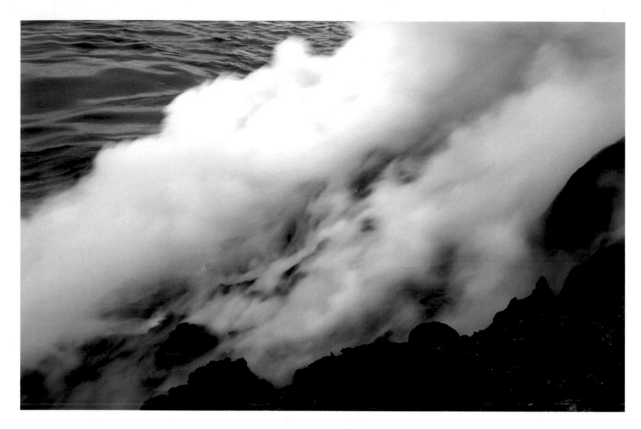

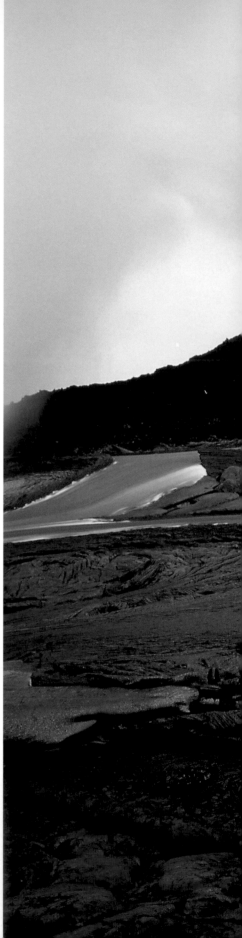

↑ Above:
Kilauea, Hawaii
The most spectacular images of Kilauea are taken at night, when the vivid orange of the molten lava stands out against the black of the sky.

→ Right:
Kilauea, Hawaii
A typical volcanic landscape at Kilauea, showing the recently solidified lava in the foreground. Walking in this terrain can be extremely dangerous, because the crust that has formed on top of molten rock can be very fragile.

Simon Fraser

Another fan of Kilauea is photographer Simon Fraser, who recalls the challenge demanded by the volcano's changeable nature. "I came to expect something different every day," he says, "because the area where the activity was taking place was liable to change at a moment's notice. The only way that I could really keep a check on things was through the local radio and a website, www.volcanoes.com, that had details of all the latest activity."

For Fraser, photographing at night is best. "I would aim to get myself into position before sunset, and the sky would get dark in half an hour. The most dramatic pictures are taken at night when the glow of the hot lava is at its best, although there is plenty to photograph during daylight hours, such as the steam plumes and the magmatic explosions."

On the coastline, as the lava cools on contact with seawater, large areas of apparently solid basaltic rock can form, which can take the inexperienced photographer by surprise. "Although the surface has solidified," says Fraser, "this kind of rock can have an unstable base and, if someone walks across it, it could collapse." But Fraser considers the risks worthwhile. "Somewhere like Kilauea is relatively benign in volcanic terms," he says. "The lava flow there has a high water content, and the way that it flows is fairly predictable, giving you time to move your position. The dangerous eruptions are the ones such as Mount St. Helens in Washington State, where millions of tons of rock and dust can head your way at something like 300mph [500km/h]."

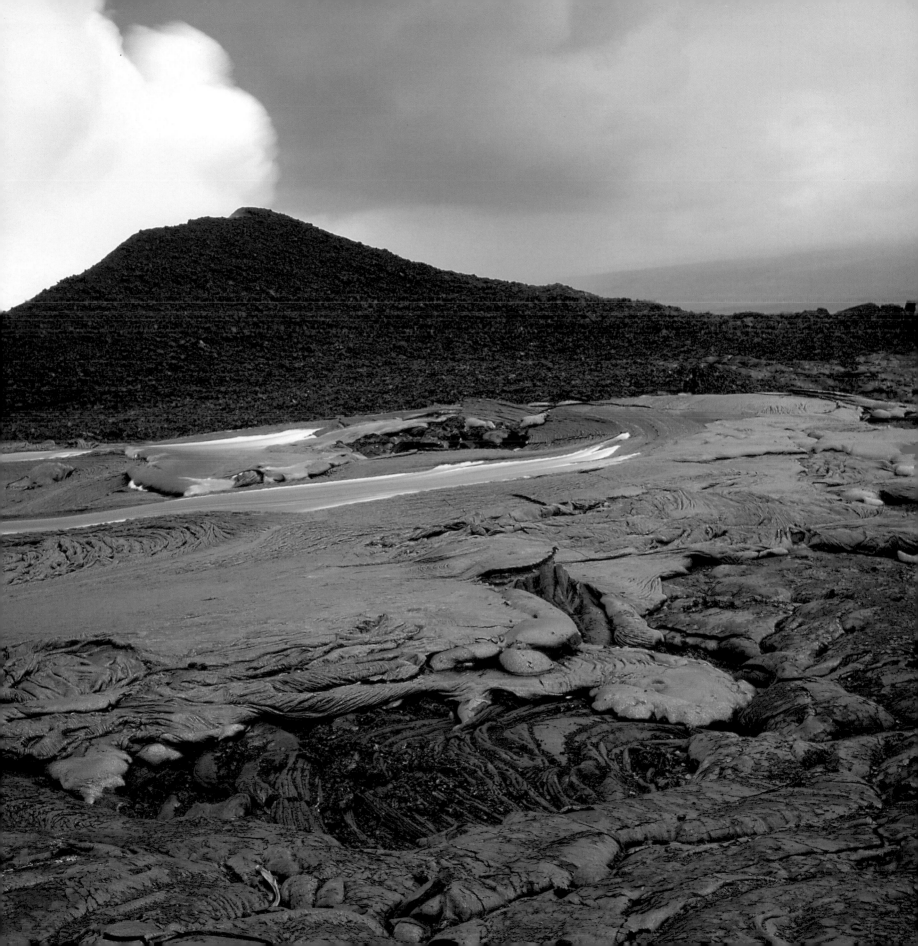

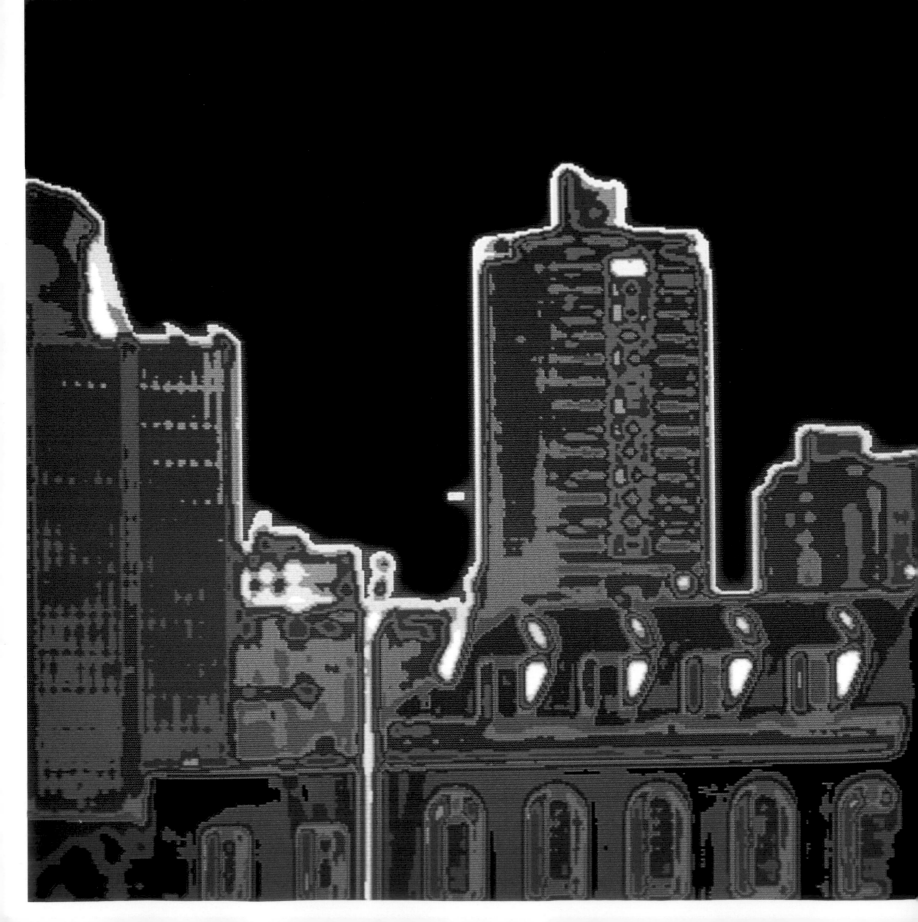

Thermography

The infrared imager is capable of seeing heat or thermal energy, and its uses vary from locating victims in burning buildings to detecting breast cancer.

While the conventional camera records what the eye can see, it is capturing only the narrow middle band of the spectrum. In contrast to the camera, the thermal infrared imager is capable of "seeing" heat or thermal energy, which is transmitted in the infrared light band that occurs at the extreme end of the spectrum (from 1 micron to 100 microns). The imager processes this into a visible light spectrum video display.

Because all objects above 0 Kelvin emit thermal infrared energy, thermal imagers can passively "see" all objects, regardless of ambient light. This allows thermal infrared imagers to perform a role as a night-vision camera (see "The Darkest", page 112, for more on night-vision technology).

A more important function of thermography is that it can relay information about the specific temperatures being given off by objects in a landscape. For example, it shows up faulty or overheating electrical connections, or weakened insulators, making this technology a crucial part of the testing procedure of many major plant operators. By scanning substations, distribution lighting panels, and electrical motors, problems can be tackled instantly, before they result in potentially costly system failure and operation downtime.

Thermography also indicates heat escaping through the roof of a building, showing immediately where a section of damaged insulation might be found, or where further insulation is required to prevent heat loss. The heat generated by a human body is also detectable by thermography, so the process is invaluable for search-and-rescue and security operations. Body heat is not easily disguised, as infrared energy is transferred when objects are touching, and any disguising material would warm up quickly .

← **Left:**
City buildings
This is a thermogram showing the distribution of heat over city buildings. The color coding ranges from yellow and red for the warmest areas (greatest heat loss) through pink to purple and green for the coolest areas (lowest heat loss). Typically, roofs and windows show greatest heat loss. Thermograms are often used to check buildings for heat loss, so that they can be made more energy efficient through improved insulation.
(Picture: Science Photo Library)

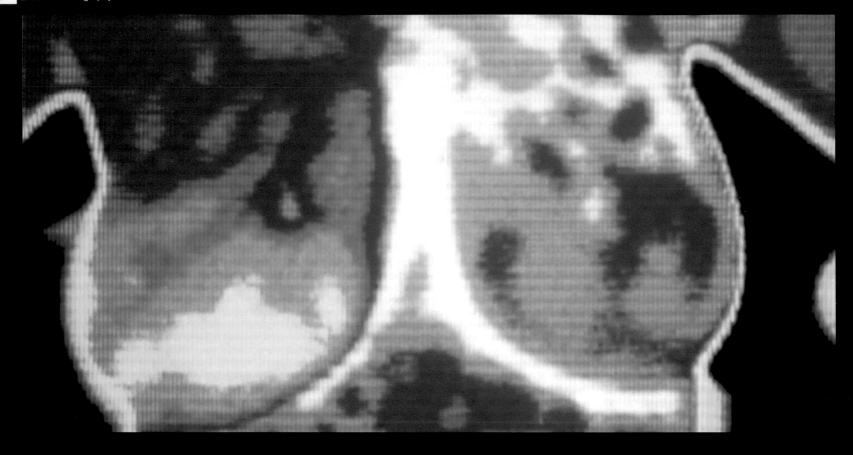

↑ Above:
Breast cancer
This thermogram shows the increased skin temperature over a cancerous left breast. This infrared image is color-coded in steps of 1° C, where blue is the coldest and yellow the hottest.

→ Right:
Body heat
The color coding in this image of a couple kissing ranges from yellow and red for the warmest areas (greatest heat loss) through pink to purple and green for the coolest areas (lowest heat loss).

The applications

Thermal infrared imagers come in different configurations to suit specific needs, and are available for commercial applications at rapidly decreasing prices. Radiometric imagers provide temperature measurement of a scene, along with a color video representation, and are used mainly in industry for predictive maintenance, process control, research and development, and in medicine.

Other imagers are designed primarily for surveillance and/or target acquisition environments, and they can be hand-held or used remotely on a fixed mount. The differences that can be found in surveillance units revolve around the optical components and the resolution of the imager. High-end units are capable of human detection at over one mile and vehicle detection at up to five miles (1.6—8km).

Imagers are used by law-enforcement agencies and electronic news-gathering teams in surveillance. They are mounted to aircraft in gyro-stabilized, all-weather housings, and, typically, are remote controlled to work singly, or in combination with a CCD TV camera.

Uses

· Thermal heat loss and electrical inspections for buildings, plants, and refineries
· Concrete integrity inspections
· Non-destructive testing
· Equine preventative check-ups
· Breast cancer detection
· Verification of soft-tissue injury
· Flammable liquid detection in drums and storage tanks during a fire
· Victim location in smoke-filled buildings
· Oil spill location
· Wildlife observation and control
· Traffic reports in bad weather conditions
· Engine/system diagnostics

the coldest

→Battling the elements →Freezing in space

The coldest places on our planet still pose a challenge to photographers, despite technical advances. Human endurance is a vital ingredient, and modern cameras fare less well than their predecessors in icy weather. Everything is relative, however, and there are also imaging devices designed specifically for conditions of extreme cold, such as the Near Infrared camera on the Hubble telescope.

Battling the elements

Pioneers of photographing in extreme cold, Herbert Ponting and Bryan Alexander are preeminent in their field, risking their lives to record the events and landscapes of the globe's most challenging locations.

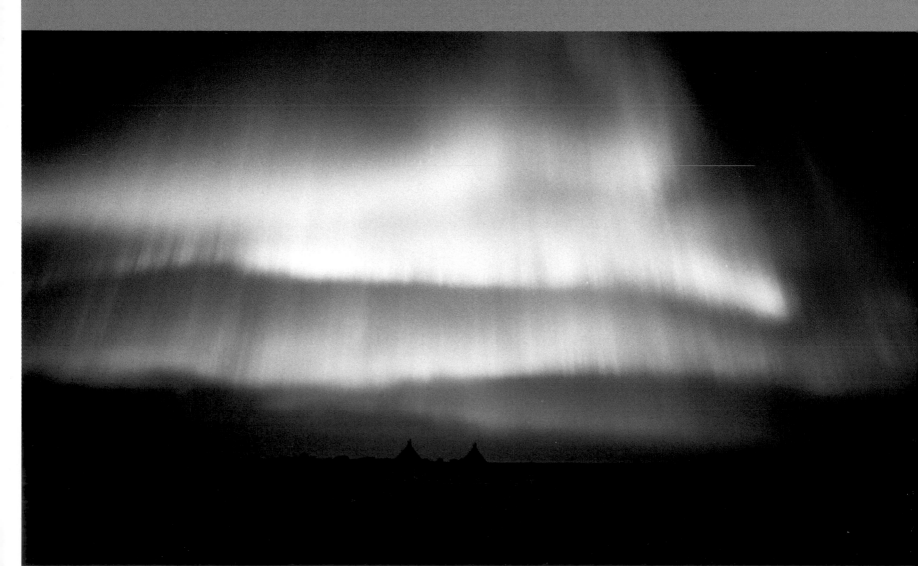

Herbert Ponting

Herbert Ponting was the acclaimed photographer and cinematographer on
Captain Scott's second, ill-fated attempt to reach the South Pole. The images
he produced of the voyage of Scott's ship, the Terra Nova, and the time that the
expedition party spent on the ice, are among the finest records ever made of
a major expedition. Ponting faced severe hardships throughout his time in the
Antarctic in 1910–11, and escaped with his life on more than one occasion.
He wrote extensively about his experiences and, from the perspective of the
twenty-first century, this makes fascinating reading. "Photographing in such
extremely low-zero temperatures necessitates a great deal of care," he recounted.
"There are many pitfalls, into all of which I plunged headlong.

"I found that it was always advisable to leave cameras in their cases outside the
hut. There is sometimes a difference of more than 100° between the exterior
and interior temperature. To bring cameras inside was to subject them to such
condensation that they became dripping wet as they came into the warm air."
Breathing on the lens was also hazardous, covering it with a film of ice that was
impossible to remove in the field. Ponting lubricated every part of his cameras
with graphite but even so, some of his shutters had to be discarded and his
exposures made through what he described as "makeshift expedients."

After a batch of plates was ruined by the cold, great care was taken to protect
the rest. "There was not sufficient room in the hut to store my entire stock,"
Ponting wrote, "so the supply in the darkroom was replenished from time to time,
from the stores outside in the snow. Plates had to be brought indoors gradually in
order to prevent unsightly markings. This took two days. I placed them for a day in
the vestibule, then … another day in my room, to accustom them to the
temperature before opening."

Loading the film camera was an unpleasant task, because gloves were too thick
to wear, and the cold metal caused frostbite. "Such frostbite feels exactly like a
burn," Ponting wrote. "On one occasion my tongue came into contact with a metal
part of one of my cameras, whilst moistening my lips as I was focusing. It froze
fast instantaneously; and to release myself I had to jerk it away, leaving the skin
of the end of my tongue sticking to the camera, and my mouth bled so profusely
that I had to gag it with a handkerchief."

A great adventurer, Ponting survived the expedition, and spent the remainder of
his life promoting his pictures to ensure that the memory of a brave, but tragic,
attempt took its place in history.

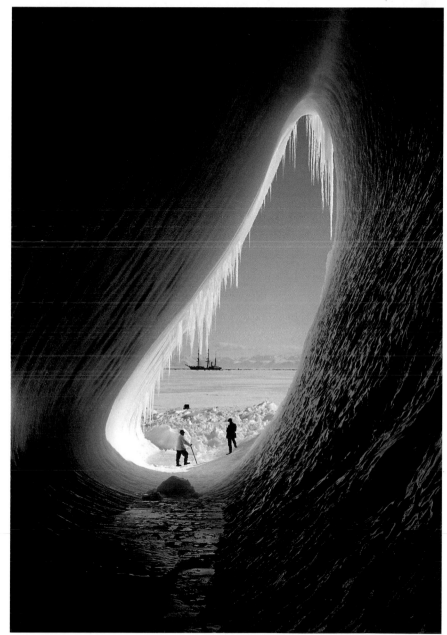

← **Facing opposite:**
Aurora borealis
The Northern Lights seen over a Nenets
reindeer herder's camp on the Yamal Peninsula,
West Siberia, Russia. (Picture: Bryan Alexander)

↑ **Above:**
The Terra Nova
Taken on Captain Scott's Antarctic expedition
of 1911 — 12, this famous Herbert Ponting
image shows the Terra Nova framed by the
mouth of an ice grotto. (Picture: Popperfoto)

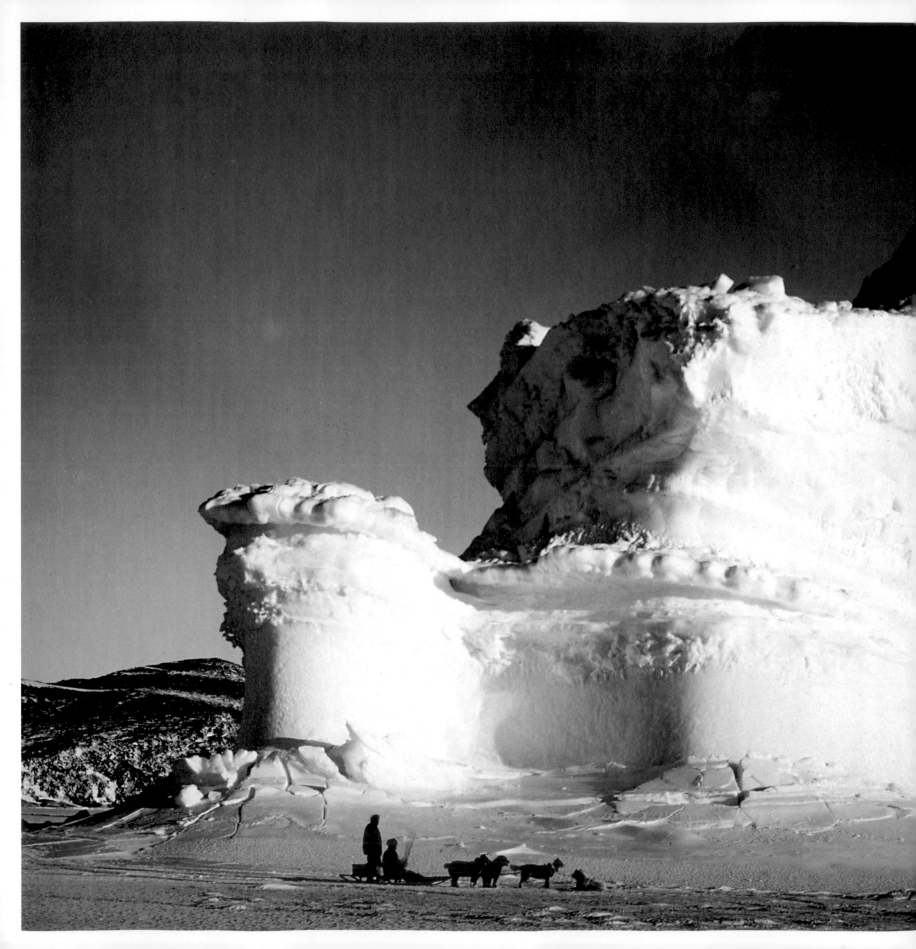

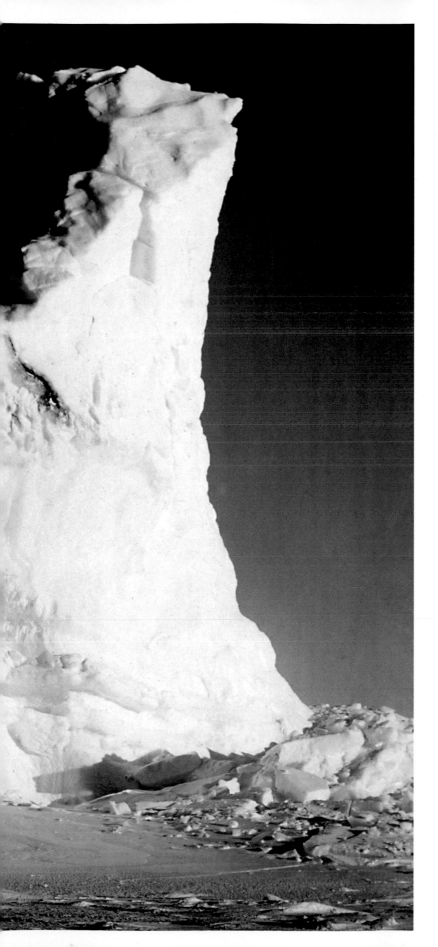

← **Iceberg, Antarctica**
A team of dogs and a sledge provide the perfect contrast of black against white, man against nature in this classic image by Herbert Ponting. (Picture: Royal Geographic Society)

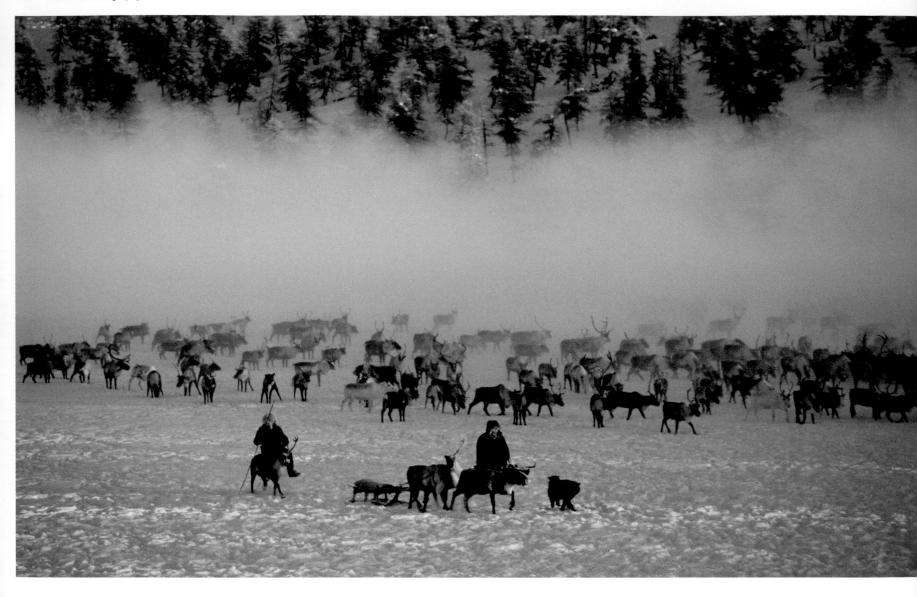

↑ **Above:**
Herders, Siberia
Herders with their reindeer at their winter
pastures near Verkhoyansk, Yakutia,
Siberia, Russia.

Bryan Alexander

Alexander has learned to live with temperatures that
can plunge to –53° C, and the camera gear that he
takes with him must be capable of standing up to
such extremes. Any equipment failure while on a
shoot—which can last for several months—would
be impossible to rectify.

The surprise is that Alexander chooses not to work
with the latest high-tech digital models, and instead
steadfastly packs his bag with fully manual Canon F1
SLR cameras, which would be considered outmoded
by many professionals. He finds these cameras far
more reliable than their modern-day equivalents
because they are totally manual, and so are not as
reliant on batteries. The controls are also larger,

making them easier to handle when working with
two pairs of gloves. Alexander usually travels with
three F1 bodies. He has cameras mothballed for
future use, and others that are used for spares.

Some photographers "winterize" their cameras, which
involves stripping them out and applying special
grease for freezing conditions, but Alexander finds
that this creates as many problems as it solves:
"Moving parts in the camera, particularly the focusing
mechanism, become very loose when the temperature
warms up," he says. "My cameras may be used in
cold weather for long periods, but they are also used
inside as well, and they would become difficult to use
in those conditions."

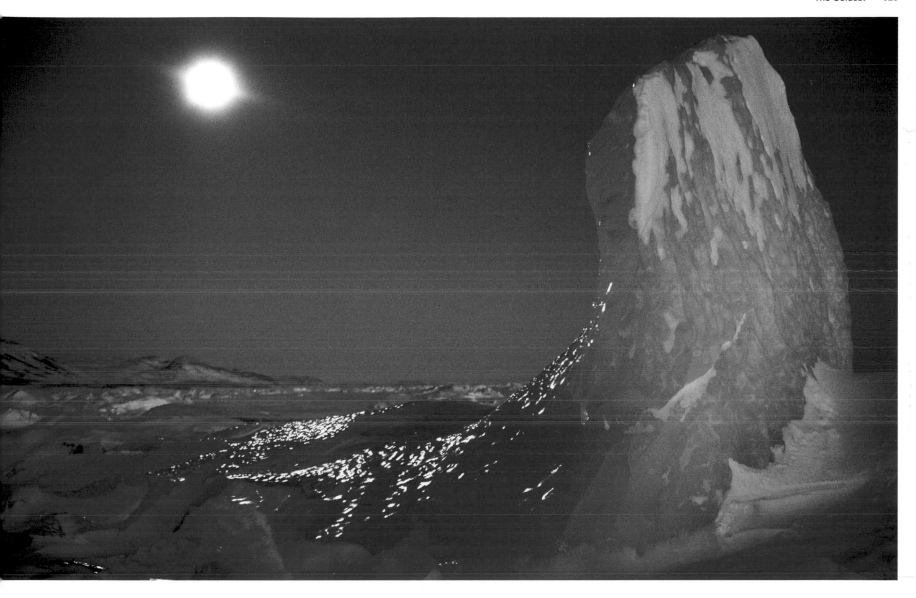

In extreme cold, the cameras become difficult to operate. He has to take great care when winding on, because film becomes brittle at low temperatures, and can easily be shattered. While the cameras are manual, they do require battery power. Formerly, Alexander used mercury cells, which performed well in the cold, but when these were discontinued, he successfully tested zinc and air batteries in the freezers of the Polar Research Institute in Cambridge, UK, and finds them to be an excellent substitute. Like Ponting, Alexander has problems with condensation if cameras are moved from freezing to indoor temperatures—ice can form, damaging the equipment. To avoid this, he wraps his gear in a plastic bag, and leaves it tied to his sledge.

"The coldest conditions I've worked in have been −59° C in Siberia," says Alexander. "It sounds bad, but it's worse if it's −30° and there is a 40mph [60km/h] wind blowing. When it is really cold, the sky is a wonderful blue. It can make it difficult to show that you are in extreme conditions!"

A major challenge for Alexander is how to keep the body—most particularly, his fingers—warm while working. He wears two pairs of special woollen gloves, and, on extended trips, dresses in the same clothes as his subjects. But the animal skins are not tanned, so become unsuitable for future trips. "In a warmer climate they would quickly rot," says Alexander, "so I've bought big deep freezers, and keep all my favorite skins in these between trips!"

↑ **Above:**
Iceberg, Greenland
Moonlit iceberg in northwest Greenland, photographed at midday during the polar night The highly reflective nature of this chunk of ice is the result of its surface being polished by the wind.

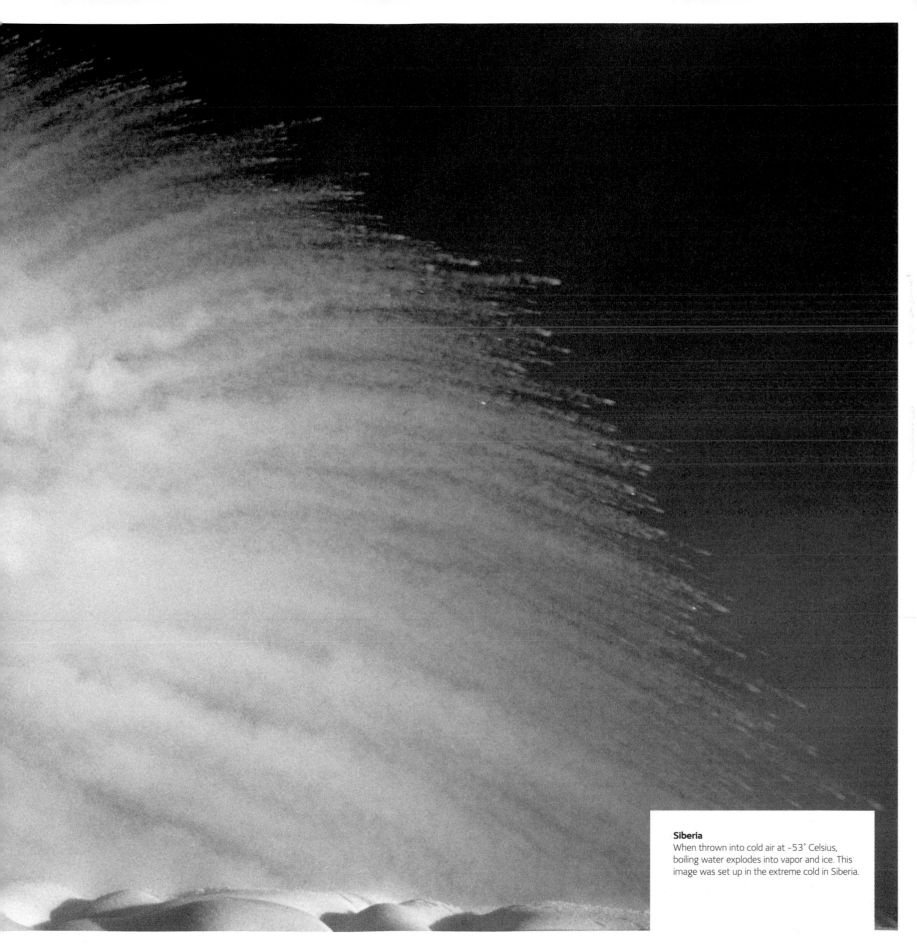

Siberia
When thrown into cold air at –53° Celsius, boiling water explodes into vapor and ice. This image was set up in the extreme cold in Siberia.

Freezing in space

NICMOS, the Near Infrared Camera/Multi-Object Spectrometer, was installed on the Hubble Space Telescope (HST) during the satellite's second servicing mission. It gave astronomers their first clear view of the universe at near-infrared wavelengths.

The function of infrared imaging is a crucial one. It penetrates the interstellar gas and dust that block visible light, to reveal invisible stars, solar systems, and galaxies, enabling astronomers to probe the universe's past, present, and future, and to study how galaxies, stars, and planetary systems form. Moreover, the light from distant objects, receding as the universe expands, shifts into infrared wavelengths (called "red-shift").

NICMOS has three channels, which enable it to make spectroscopic observations of astronomical targets and infrared (IR) imaging. Just as a camera for recording visible light must be dark inside to avoid exposure to unwanted light, a camera for recording infrared light must be excessively cold inside in order to capture the warm glow radiated by the objects being photographed. The instrument's detectors must be at temperatures of below -351° F (-213° C) too, as photoconductive infrared detectors, when warm, effectively generate their own glow (called "dark current"). Less than a square inch (2.5sq cm) in size, they are cooled inside a cryostat (a thermally insulated container, much like a thermos bottle).

When NICMOS was installed, in 1997, its cryostat contained a 230lb (100kg) block of nitrogen ice. However, soon after NICMOS became operational, an unexpected heat source was detected and it was apparent that the nitrogen ice would be prematurely depleted in two, rather than the expected five, years. To compensate, it was agreed that Hubble would perform more NICMOS observations than originally scheduled in its two years of operation— but the setback to infrared science remained.

NASA scientists and engineers devised a plan to restore NICMOS to life, and they turned to new mechanical cooling technology, jointly developed by NASA and the US Air Force. The system operates on principles similar to a domestic refrigerator, and involves pumping ultra-cold neon gas through the instrument's internal plumbing. At the core of the mechanical cooler are three miniature high-tech turbines that spin at rates of 430,000 rpm. Since the speed can be adjusted at will, the NICMOS light sensors can be operated at a slightly higher temperature than before—at -321° F.

As an added benefit, the NICMOS cooling system is virtually vibration-free, which is an important consideration since any vibration could affect image quality in much the same way that a shaky camera can produce blurred pictures. The new cooling system was installed on March 8, 2002, during a complicated space walk, and it was turned on via commands from the Space Telescope Operations Control Center at Goddard Space Flight Center on March 18, reaching its required working temperature on April 11. NICMOS began to operate a week later. After more than three years of inactivity, it reopened its "near-infrared eyes" on the universe, snapping several breathtaking views, from the craggy interior of a star-forming cloud to a revealing look at the heart of an edge-on galaxy. The camera's penetrating vision sliced through the edge-on dusty disk of a galaxy much like the Milky Way to peer all the way into the galaxy's core. The first new images were released on June 5, 2002, and proved beyond doubt that this spectacular piece of imaging technology was back on track.

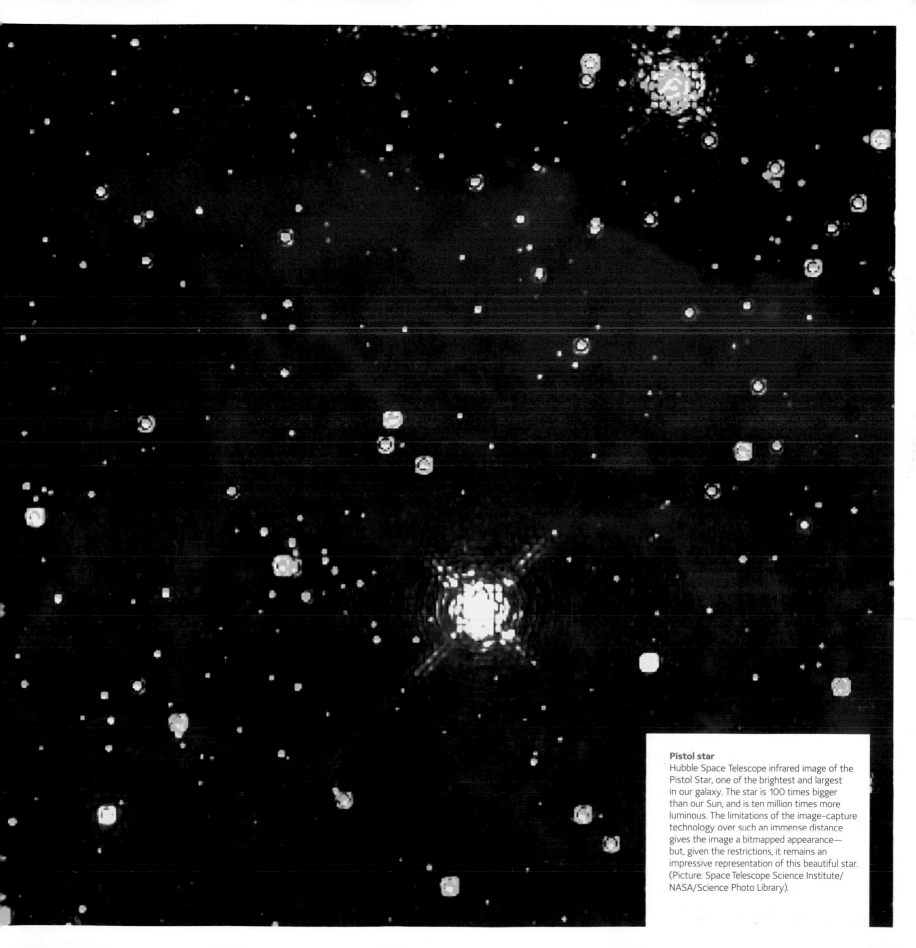

Pistol star
Hubble Space Telescope infrared image of the Pistol Star, one of the brightest and largest in our galaxy. The star is 100 times bigger than our Sun, and is ten million times more luminous. The limitations of the image-capture technology over such an immense distance gives the image a bitmapped appearance—but, given the restrictions, it remains an impressive representation of this beautiful star. (Picture: Space Telescope Science Institute/NASA/Science Photo Library).

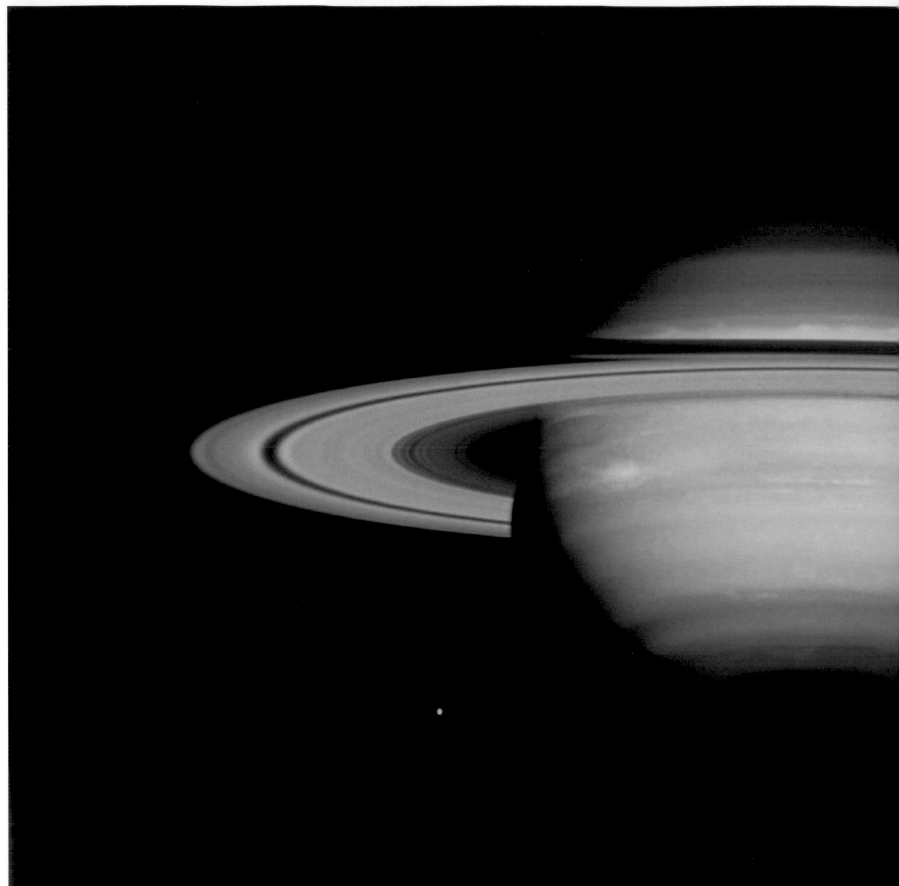

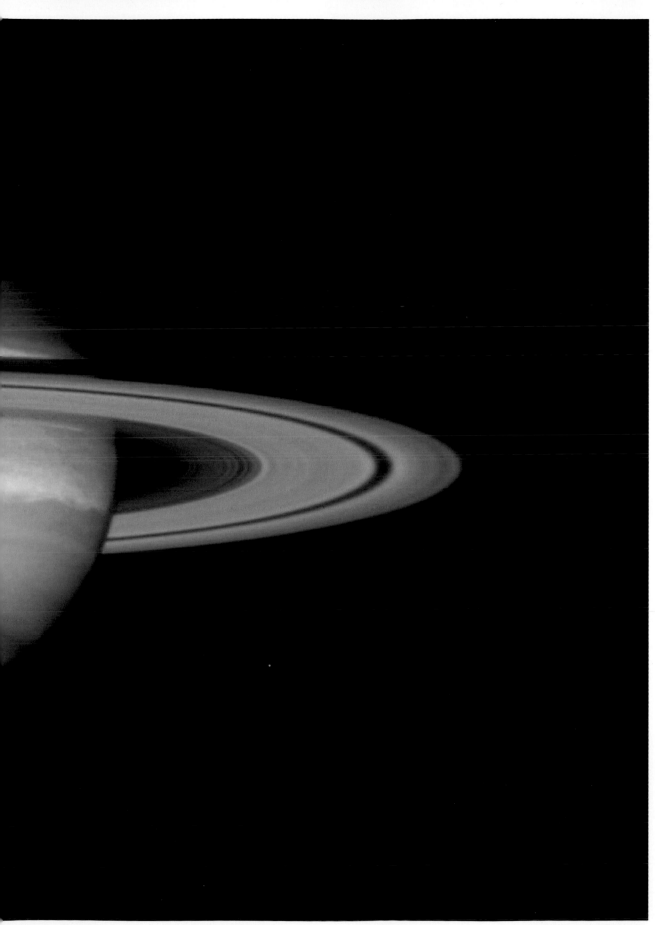

← **Left:**
Saturn
This Hubble Space Telescope image shows the varying cloud levels in its atmosphere. Blue areas show a clear atmosphere down to the main cloud layer, whilst green and yellow areas show atmospheric haze above the cloud. Red and orange areas represent clouds reaching high into the atmosphere, whilst the dark region around the south pole is a hole in the cloud layer. The equatorial rings are composed of chunks of ice. (Picture: Space Telescope Science Institute/NASA/Science Photo Library)

the
fastest

→Speed freak →At high speed →Up close and personal

High-speed photography captures movement that is too fast for the human eye, opening up a fantastic perspective on the world. It gives us an image of the invisible split-second and enables us to pin down decisive moments from a fast-moving event—and it has given us some incredible pictures, while also pushing back the boundaries of human knowledge.

Speed freak

One of the "characters" of the Victorian era, Eadweard Muybridge was an early pioneer of high-speed photography.

→ Right:
High-speed image of a horse and rider
Eadweard Muybridge was a pioneer of high-speed photography, and captured sequences in the late nineteenth century that helped to explain the reality of animal movement. (Picture: Science Photo Library)

Based in San Francisco, Muybridge established himself early on as one of the outstanding landscape photographers in the West. In 1872 he received an invitation from Leland Stanford, builder of the Central Pacific Railroad, to photograph his horses. Stanford wanted to answer the question of whether there were moments during a gallop when all four hooves of the horse were clear of the ground.

In 1874, after a period of controversial "exile", Muybridge returned to the United States with a set of Scovill cameras fitted with Dallmeyer lenses, and returned to his commissioned work. Using an outdoor track, he aligned twelve cameras opposite 15-foot (4.6m) high sheeting, marked off with numbered lines. The camera shutters were attached by an electrical contact to threads of galvanized cotton stretched across the horse's path, and these were tripped in succession by the animal as it raced down the track. By 1878 Muybridge had produced his first photographs, although the restrictions of the wet-plate process meant that the images were just a black silhouette. However, the pictures established that there *were* moments when all four hooves were airborne. The results spurred Muybridge to buy first 20, then 24 cameras. By 1879 he was photographing other animals, and people.

Muybridge next made the tantalizing crossover into "moving" images with his "zoopraxiscope"—a magic lantern combined with two counter-rotating disks. This gave Muybridge a tool with which to enthrall the masses during his lectures. By 1885 he had perfected his technique, and was photographing athletes in motion. In 1887 his seminal work, *Animal Locomotion,* was published, which offered a unique insight into natural movement, and booked Muybridge's place in history as one of the most progressive early photographers.

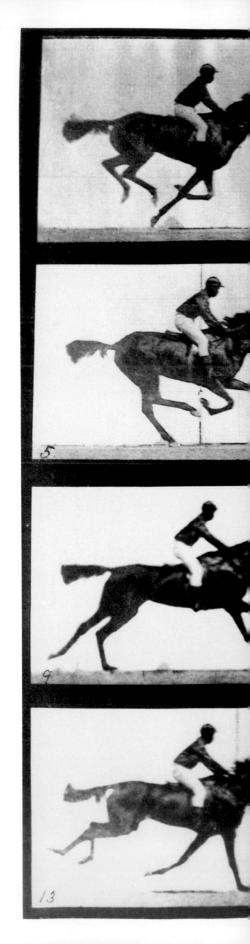

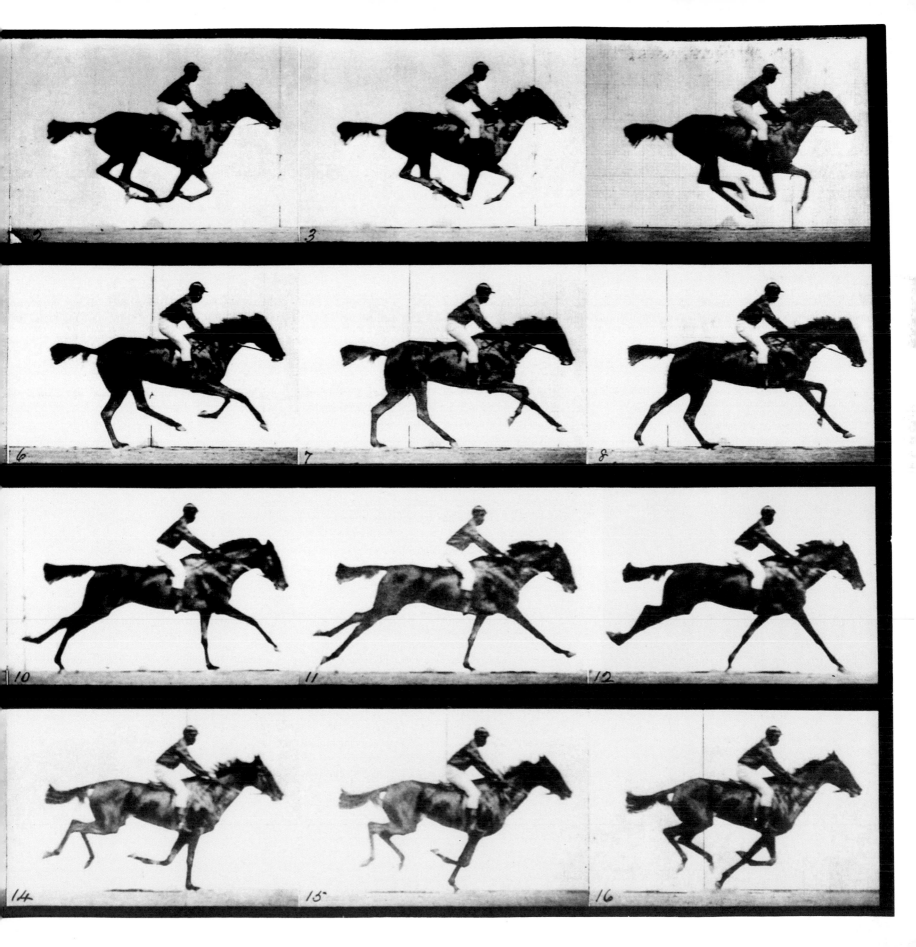

At high speed

Over the years, there have been a number of photographic innovators who have been fascinated by, and experimented with, capturing the frozen movement of extremely fast-moving subjects. Dr. Harold Edgerton was a leading exponent, and inspired generations of photographers.

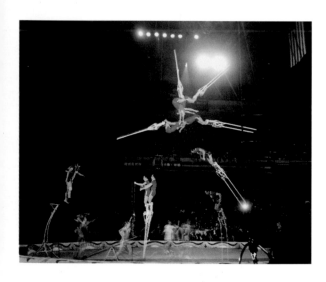

↑ **Above:**
High-speed image of circus tumblers
The tumbler act of the Russian Circus at the Boston Garden. (Picture: Dr. Harold Edgerton/ Science Photo Library)

→ **Right:**
Edgerton's high-speed milk drop splash
This milk drop splash on to a plate covered by a thin layer of milk is one of Dr. Harold Edgerton's most famous images, and demonstrates the capability of the stroboscope that he had developed. (Picture: Dr. Harold Edgerton/Science Photo Library)

Dr. Harold Edgerton

Fascinated by capturing high-speed action, many photographers have built on Muybridge's early achievements. Dr. Harold Edgerton has also made an immense contribution to the recording of movement in photography. His observations in 1925, while researching for the General Electrical Company in Schenectady, New York, led him to develop his own sequential flash device. Edgerton noticed that the bright flashes of a mercury-arc rectifier, used to send power surges to a large electric motor, could make the spinning parts of the turning motor look as though they were standing still. From this he developed what he called a "stroboscope", capable of emitting 60 ten-microsecond charges per second. He soon added a camera to record the results.

Edgerton's first images were made with a movie camera that was perfectly synchronized with his equipment so that each flash exposed a single frame of film. Projected at normal speed, the movement of the motor could be studied in slow motion.

At the Massachusetts Institute of Technology, Edgerton started to look for commercial applications for his stroboscope. He formed a partnership with two of his graduate students for its manufacture and sale, and filed for his first patent in 1933. The next year he turned exclusively to photography, and from 1937 onward, he was using his single-burst gas-discharge tube to photograph everything from flying bullets to drops of liquid, the flight of insects and birds, the flow of air through fans and propellers, sports action, and materials cracking during impact.

Edgerton published two popular books: *Flash* and *Quicker 'n a Wink*, and throughout the 1940s his images were bought and exhibited by museums, reproduced on postcards, and published in *Life* and *National Geographic* magazines. The ultimate accolade was an award from the National Press Photographers' Association.

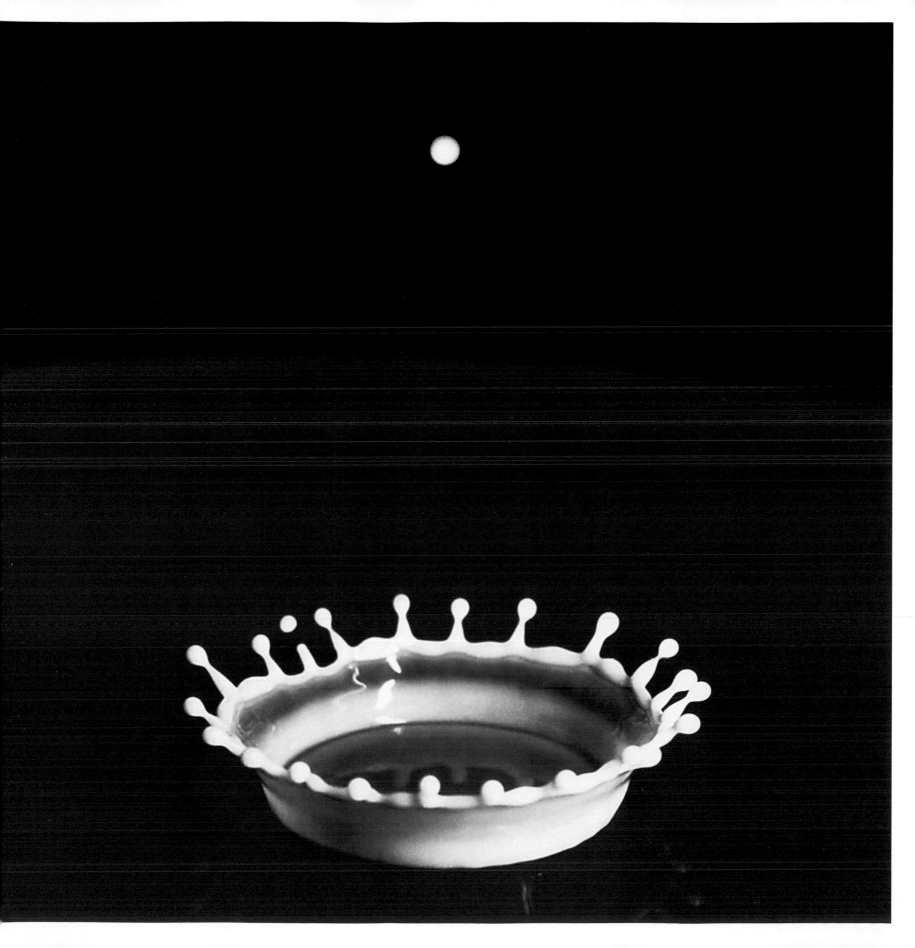

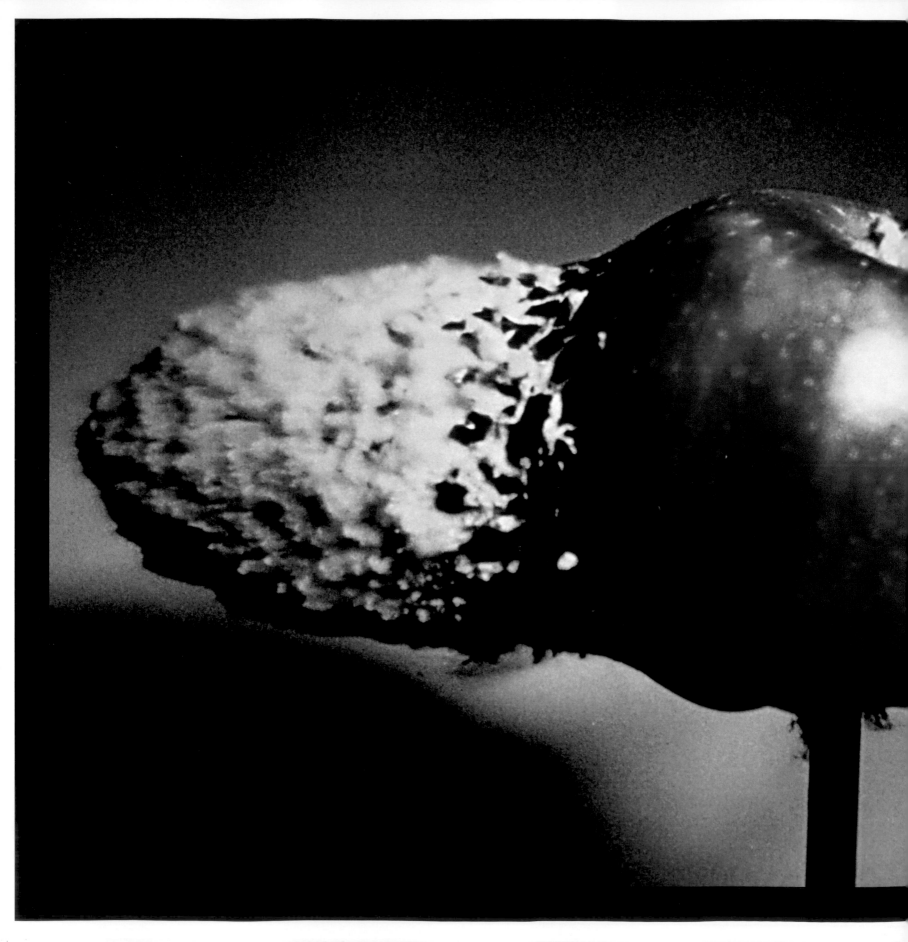

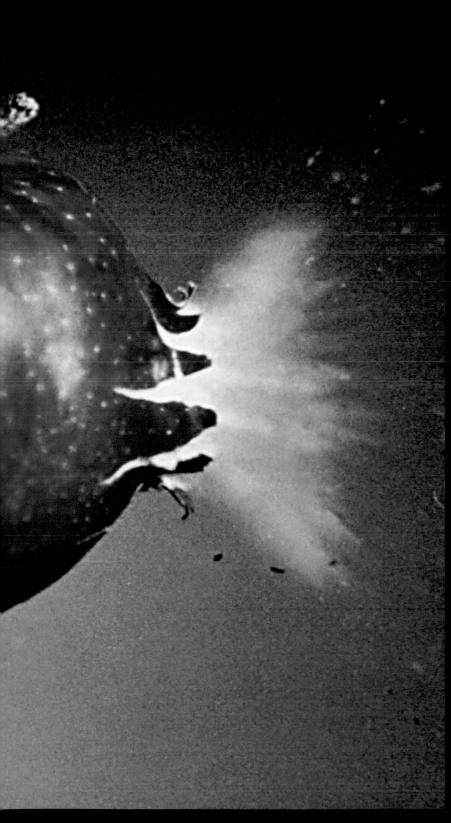

Modern high-speed photography

Today, high-speed photography relies on a combination of an extremely short exposure and almost instantaneous shutter fire. Conventional mechanical shutters can achieve shutter speeds of 1/10,000sec, but this is sometimes not fast enough to capture extreme movement. Many high-speed photographers work with short-duration flash illumination sources—either spark or electronic flashes —which can provide exposures ranging from milliseconds to less than a microsecond.

With exposures this short, synchronizers that are activated through the detection of an imminent high-speed event, are used to trigger either the camera or a light source (or sometimes both), to enable the shutter to be fired at exactly the right time. The most frequent triggers are light beams, sound, or changes in pressure, strain, temperature, or motion. Typically the synchronizer will feature an adjustable delay, so that the photograph is taken at a predetermined time after the detection of the signal.

Still in use today, particularly for capturing repetitive movement, is Dr. Edgerton's stroboscope. The mechanical version is a rotating disk with one or more "slots" cut into it at regular intervals, and the electronic stroboscope is a short-duration electronic flash with a very fast recycling time, enabling it to trigger at variable and calibrated time intervals.

When the repeat time period of a recurring event is the same as that of the time between the light flashes the effect is to make the event motionless, provided that the ambient light level is low in comparison to the light produced by the flash. The reason for this is that the eye can only see by the light of the flash, and each flash occurs when the subject is at exactly the same point.

As an expansion of this, intriguing photographs of a moving subject can be recorded on to a single frame of film by illuminating the subject with a flashing stroboscope while the subject is moving against a dark background. While the camera shutter is held open, those parts of the subject that are in different locations at the time of each light flash will be recorded on different locations of the film: with a stroboscope set to a speed of 60 flashes per second and the shutter open for half a second, for example, a film could register a subject in 30 different positions.

← **Left:**
Exploding apple
This high-speed photograph by Dr. Harold Edgerton of an apple being struck by a high-velocity bullet relied on an exposure time of just a third of a micro second.
(Picture: Science Photo Library)

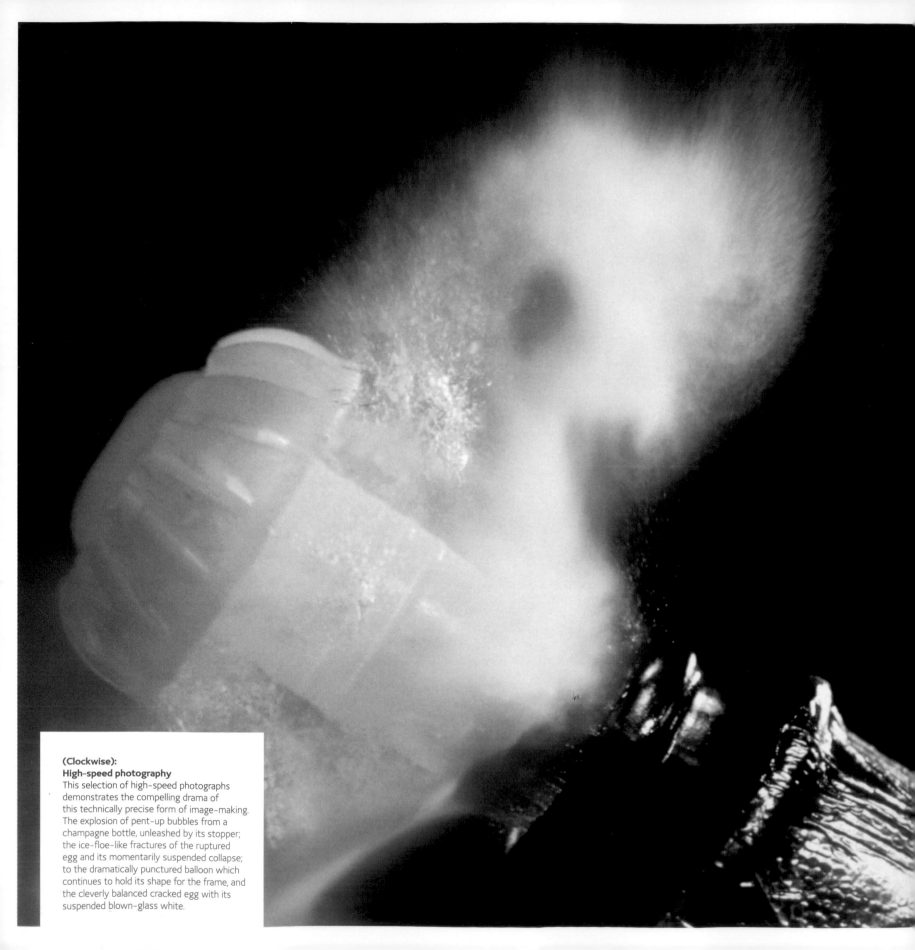

(Clockwise):
High-speed photography
This selection of high-speed photographs demonstrates the compelling drama of this technically precise form of image-making. The explosion of pent-up bubbles from a champagne bottle, unleashed by its stopper; the ice-floe-like fractures of the ruptured egg and its momentarily suspended collapse; to the dramatically punctured balloon which continues to hold its shape for the frame, and the cleverly balanced cracked egg with its suspended blown-glass white.

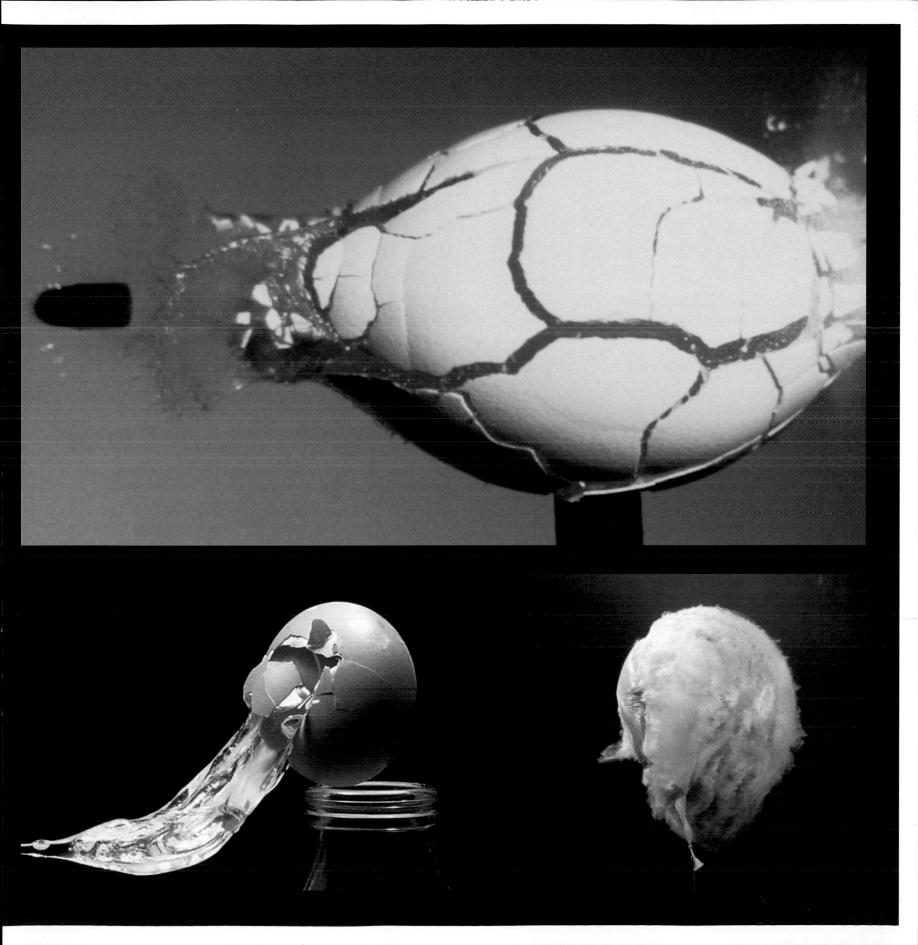

Up close and personal

Today, practitioners of high-speed photography work in diverse, and often completely unrelated areas—from extreme sports to macrophotography.

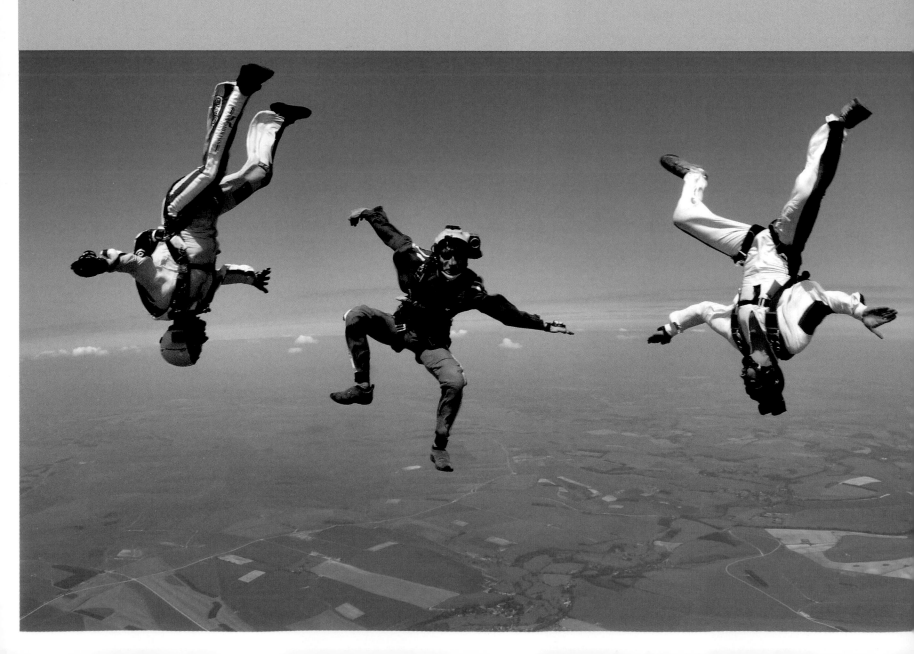

Simon Ward

Speed is an essential ingredient in the life of adventure photographer Simon Ward, who regularly tackles assignments that would justifiably terrify most of us. One activity Simon Ward specializes in is wing-walking. He has also base-jumped off structures as the Clifton suspension bridge in the UK, skydived on to the North Pole, and down the Eiger North Face, and filmed numerous world records, including the world's highest bungee jump at 11,200 feet (3,414m)—from a hot air balloon.

Ward has been skydiving since 1979, and has over 4,000 jumps to his credit. On most of these occasions he's photographed other skydivers, making him one of the world's most experienced photographers of this sport. The demands are enormous: Ward must freefall through the air at up to 200mph (320km/h) while trying to execute his pictures, and the battery of cameras he uses are fastened to his helmet, denying him the chance to frame the shots in a conventional way.

"Although you are travelling this fast, you're working relative to other people who are travelling at the same speed," he says, "so you don't really notice it until someone's chute opens and they fly upward. I need both hands free to direct myself and to carry out what I need to do as a skydiver, so having the camera on the helmet is the only option. I'll normally have two cameras with me but will jump with up to four—a movie or video camera and a digital camera. I know what the various lenses offer me, and I'll frame the pictures that I want by positioning myself in the right way."

Ward works close up to his subjects, and his favorite still camera lens is a 16mm that allows him to include lots of the environment. It's why he hasn't converted to digital, because the interchangeable lens models capture less in a frame.

Ward adapts his still cameras so that they can be fired via a mount control. Thankfully, he can operate his movie cameras conventionally as they require less attention. But despite the challenges presented by his extreme activity, safety is his biggest priority, and the fact that he is still here to show the world his exploits, is testament to his unique skills and talent.

← **Left:**
High flyers
Gary Sweeny, Alec Cotton, and Mike Carpenter "freeflying" over Netheravon in Wiltshire, UK. (Simon Ward)

↑ **Above right:**
Insect self-portraits
Dr. John Brackenbury combines macro techniques with high-speed photography to capture remarkable images of insect life. Realizing that his own reactions are far too slow to capture his subjects, he allows them to effectively take their own picture, the action of breaking a laser beam being enough to trigger the camera and flash set up.

John Brackenbury

In the right hands, the most remarkable images can be taken of some tricky subjects: tiny, fast-moving insects. John Brackenbury is an expert in this field, and his pictures reveal the natural world in exciting new ways.

Insects are difficult to photograph in a conventional manner. Essentially, the creature takes its own picture by breaking a laser beam, an action that triggers three separate high-speed flash units, each one custom-built and capable of delivering a burst of light just 1/20,000sec long.

"The important thing is to get the shutter open as quickly as possible," says Brackenbury. "I have the shutter permanently open on the 'B' setting, and adjusting it to its widest setting. I screw an electromagnetic shutter fitted with a specialized diaphragm into the filter thread of my lens. This opens in 1/3,000sec, receiving a signal from a photocell that has detected the break. Really, it's the speed of the flash that controls the exposure. I set it to 1/30sec, and that's fine."

With this technique, the thorny issues are that, if the high speed flashes are used on a foreground subject, the background underexposes. The second is that moving insects in the direction of a pre-set laser beam is not easy. First, Brackenbury made an artificial background from a huge transparency of out-of-focus flowers. He lit his subject with two flashguns and positioned the third behind the transparency to create a backlight. Persuading his subjects to co-operate was more difficult, and Brackenbury took two years to find a remotely failsafe method. "I realized that they would instinctively fly towards the ultraviolet of the sky, so I build my sets so that there is an open window. On its way out the insect will fly through the laser beam, and the hope is that it usually takes its picture on the way."

the
slowest

→Chlorophyll art →Grass photography →Time and space

Thanks to the photosynthesizing nature of chlorophyll, green living matter can record an image. The technique has been exploited by artists, intrigued by the possibilities of combining organic material with technology-based media. But there are slower forms of receiving images. Images taken by the Hubble telescope can take up to ten days to reach Earth.

Chlorophyll art

Vietnamese-born photographer Binh Danh has developed a technique for producing images directly on to leaves, whose shape he chooses carefully to match the nature of the negative.

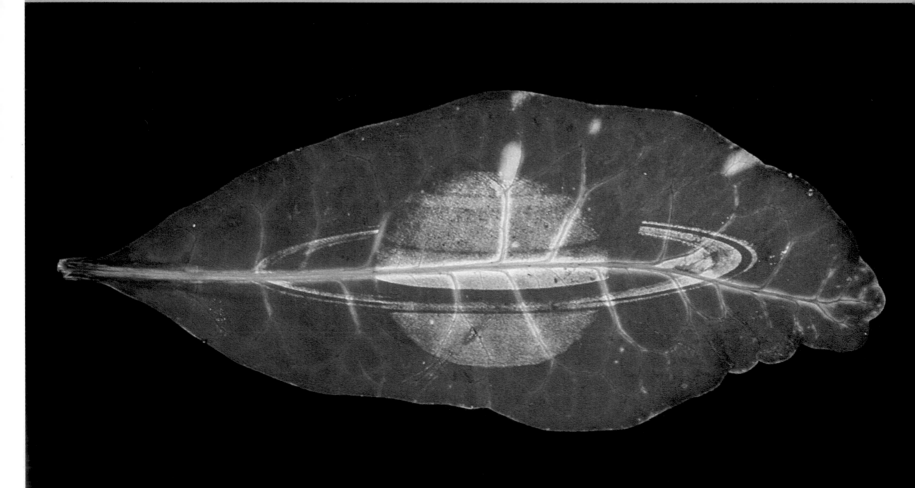

Binh Danh's photographic leaf prints are the result of the natural reaction of vegetable matter to light, combined with a tremendous amount of patience, and an artist's eye. The results look incredibly fragile, but can be remarkably durable.

"I start with images that I think have the potential to work well with the process," Binh Danh says, "and I then decide what kind of treatment to give them. Once I know what I want to do, I produce a negative to the size that I want on the computer, and then go looking for the right leaf to use. Often I'll pick one that is not perfect, perhaps because insects or the weather have damaged it, because this will add a sense of decay to the final result.

"To keep the leaf from drying, I'll fill a small bag with water and tie it around the stem of the leaf, and then I'll secure the negative to it and leave it on the top of my roof for a couple of weeks to allow it to take."

In the summer, results can be ready quite quickly, perhaps within a few days, although the leaf itself might turn brown in the heat. In fall, the reduced sunlight makes the process longer, but the leaf is likely to retain a fresher appearance.

There are several kinds of chlorophyll, the substance that ensures that leaves are green in summer. The effect of photosynthesis ensures that the leaf loses its pigmentation if it is denied sunlight. Because of this, when a negative—with its intricate areas of tone and highlight—is held tightly in position for long enough, the leaf will respond by replicating in startling detail the image that it has been in contact with.

The final image is a positive, because the darker areas of the negative—which have been created by the brightest areas of light—will mask the daylight, draining the color from the leaf, while the lighter parts of the negative, representing the dark tones and shadows, let through most light, enabling the leaf to retain much of its original coloration.

All images by Binh Danh
These beautiful, subtle images by Vietnamese-born photographer Binh Danh were created by making use of a leaf's ability to record a photographic image when exposed to a negative for several days, and they follow every twist, turn, and defect of the natural canvas. Danh's art is as much to do with his perception of which shape and color will work with which picture, as it is to do with his mastery of this very specialized printing technique.

Grass photography

Like leaves, grass is light-sensitive, and if it is denied light it won't produce chlorophyll, which is why a patch of lawn turns yellow if something is lying on it for too long. The possibilities of this appealed to artists Heather Ackroyd and Dan Harvey.

When Heather Ackroyd and Dan Harvey were putting together their first collaborative work in a small Italian village in 1990, their aim was to create an installation that centered on growing grass from seed over the interior walls of a vaulted room.

As part of the installation they had placed a ladder against the grass wall, and when they took it away they noticed that its shadow had been subtly imprinted in the grass. They started thinking about whether there was something in this that they could develop. In an installation the following year, they experimented with projecting a negative on to grass that, as before, was being grown on a vertical surface. Astonishingly, the grass ended up with a finely detailed positive photographic image etched into it.

Under controlled lighting conditions, and during a period as long as ten days, the growing grass produced chlorophyll, and hence color, according to the intensity and amount of light it received. The tonal range of a conventional black-and-white photograph is created in the grass in shades of yellow and green, and a finished image will exist as a living, organic photograph for just a finite amount of time, changing subtly in appearance as it reacts to lighting and atmospheric conditions until it simply fades away entirely.

In grass photography, size is no object. For big interior installations, the exposing stage of the procedure is carried out in a darkened room, using a powerful projector to throw a negative on to a wall that has previously been planted with fresh grass seed. The negative has to be robust to cope with the conditions that occur during the several days that it takes for the grass to react to the light being thrown upon it, and the "processing" of the image relates to the care taken to make the grass grow quickly and evenly before and during the exposure period.

The final fixing stage, which involves drying the grass, currently preserves the image for only a limited period so the transient nature of the grass pictures is an essential element of the art form. No chemicals are involved, and Ackroyd and Harvey work from a variety of negatives, ranging from 35mm right up to a specialized large format.

That the work was soon subject to decay formed part of the original installation's attraction, although the artists wanted to retain the image for longer so that it could be put on display. Scientists at the Institute of Grassland and Environmental Research in Aberystwyth, Wales, offered at least a partial solution. They had developed a new strain of grass known as "Stay Green". As it sounds, it endured even when it had been dried, which meant that it could be preserved for considerably longer periods. However, these dried-grass photographs still require the right environmental conditions to maintain the long-term visibility of the image. "We had one piece of work exhibited at the V&A in London," says Ackroyd, "in a room with very low light levels for around eight months, and it was still really quite visible after that time. Our guess was that it would have lasted over a year in those conditions. Our science colleagues think that it could, in fact, be very many years."

Images that have been grown in grass can be initially overpowering. To date the largest has measured 36ft (11m) square and, intriguingly, as you move closer to the image the detail breaks down until eventually you realize that you are walking into the print itself. Finally you're looking at individual blades of grass, each one of which looks quite ordinary but each holding information on a molecular level that is essential to the greater whole.

← **Left:**
Mother and Child
This huge image is made up of thousands of
tiny strands of growing grass, which produces
chlorophyll and changes color in relation to
the amount of light that it receives

← **Left:**
Afterlife
Another giant Ackroyd and Harvey installation. Because the process used to create such images involves projecting an image on to a wall of growing grass, the results can be as big as the exhibition area will allow.

Time and space

Cameras used in conjunction with the Hubble Space Telescope are capable of recording deep-field images from remote parts of the universe that were hitherto hardly guessed at.

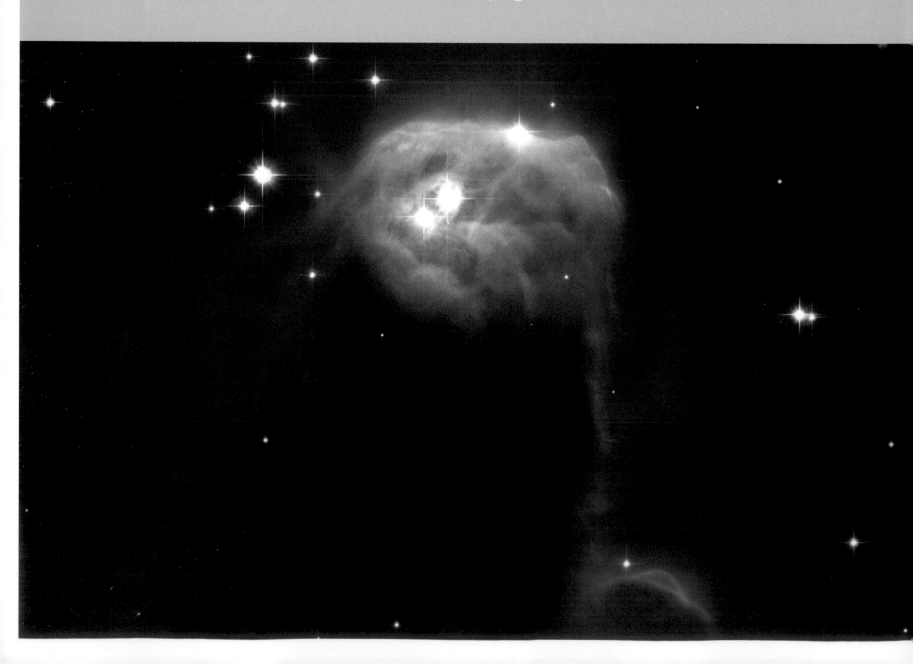

The longest exposures ever made by the Hubble Space Telescope were in the mid-1990s, when its Wide Field and Planetary Camera 2 were trained for ten-day periods on areas of the Big Dipper (Ursa Major, or Great Bear) and the Southern Cross (in the southern hemisphere). The idea was that, by directing the telescope at a point in the sky over a long period, some of the faintest galaxies would be recorded and seen for the first time.

The Big Dipper image, known as the Hubble Deep Field (HDF), was assembled from 342 exposures, which represented a tiny fraction of the sky. It was considered to be a typical representation of the galaxies.

Even within this tiny area Hubble uncovered a bewildering range of at least 1,500 galaxies, some of them dating back to the beginning of the universe. Because the "deep" or most distant objects are among the dimmest, the ten-day exposure was like using a time machine to witness the early formation of galaxies, perhaps less than one billion years after the Big Bang.

Preparing the Big Dipper image

A year of preparation preceded the first of the two observations. The HDF team selected a piece of sky near the handle of the Big Dipper. The field selected was far from the plane of our own galaxy, and thus was "uncluttered" by foreground stars, enabling a clear view to the horizon of the universe.

Staring at one spot for ten days, Hubble accumulated data by taking pictures—between 15 and 40 minutes long—one after the other, for the entire exposure time. Separate images were taken in ultraviolet, blue, red, and infrared light. By combining them into a single color, astronomers were able to infer the distances, ages, and composition of the galaxies. Astronomers processed the frames, removing cosmic rays and other artifacts, and stitched them together into a final picture. With each picture, the view got deeper. Finally, they had completed the deepest picture ever taken of the heavens.

The Advanced Camera for Surveys

When the Advanced Camera for Surveys (ACS) was installed on Hubble, it took image-gathering to a higher plane. The ACS offers dramatic improvements over previous cameras. The first image it provided, which showed the universe beyond the Tadpole Galaxy, revealed further galaxies, with the difference that the picture was obtained in just a twelfth of the time.

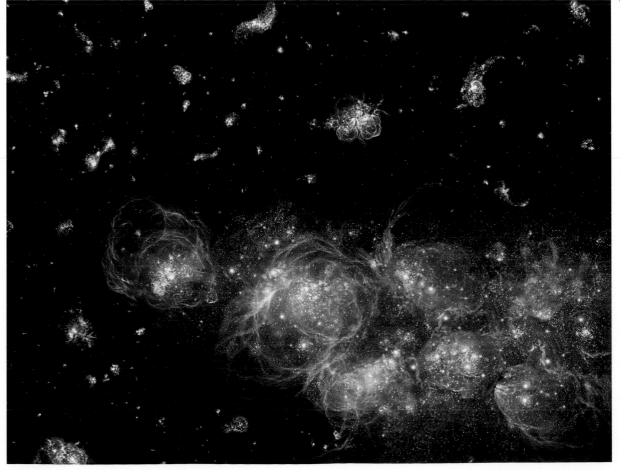

← **Far left:**
Cone Nebula
Optical image of the dark nebula taken by the new Hubble Space Telescope Advanced Camera for Surveys (ACS). The Cone Nebula is a dense, dark pillar of gas and dust seen silhouetted against part of the bright red emission nebula NGC 2264. The Cone Nebula lies around 2500 light years from Earth in the constellation Monoceros. (Picture: Space Telescope Science Institute/NASA/Science Photo Library)

← **Left:**
Star birth in the early universe
This one-billion-year-old universe is based on deep field observations by the Hubble Space Telescope. Because light has taken billions of years to reach Earth from these distances, these observations look back to the early history of the universe.

the nearest

→Photomicroscopic world →X-ray specs →Computed tomography
→An insider's view →Looking inward

Through computer technology, photography has become an invaluable medical tool, offering high-quality imagery for diagnosis that avoids invasive investigative surgery. Advances in microsurgery techniques enable the surgeon to carry out intricate operations using miniaturized surgical instruments.

Photomicroscopic world

There is an extraordinary world that is invisible to the naked eye —and it is all around us. However, by utilizing a combination of photography and sophisticated microscopes, in recent times, this world has been revealed to us, enabling scientists to document extraordinary close ups of the most minute forms.

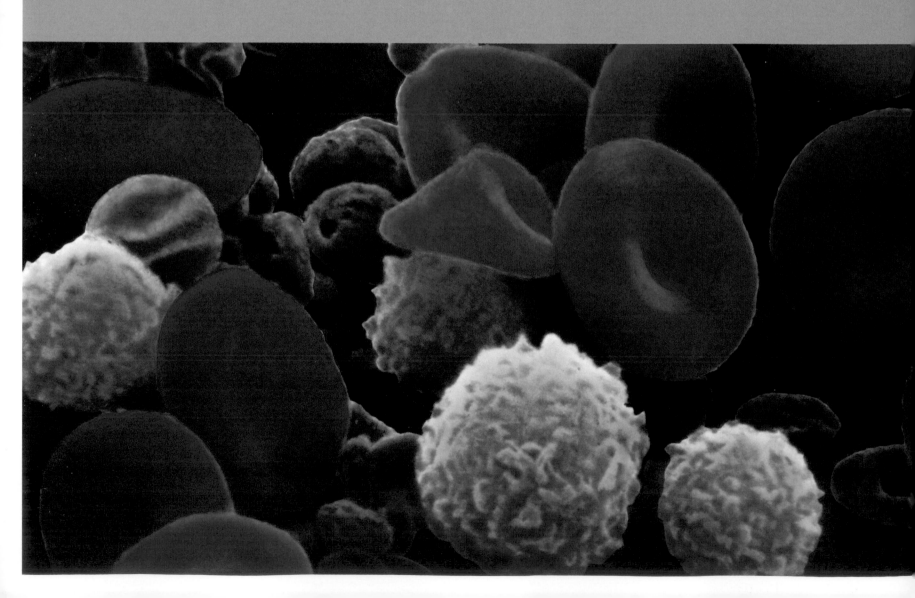

Wonders of the world

With photomicroscopy, the most mundane of creatures and household objects suddenly has an intricacy of form and pattern that has previously eluded us. The ability to provide this level of detail has invaluable medical and scientific application, of course, but for the layperson it is also a visual manifestation of something else—a reminder of the wonders that we take for granted, and a unique insight into the cutting-edge research that determines to cure viruses and diseases that were once beyond our understanding. Without the microscope the human eye has a limited resolving power. As a result, while it might be possible for the blunted point of an ordinary household pin to be visible, even the most keen-sighted of us would not be able to perceive the potentially lethal bacteria that might be sitting on its tip.

Since its invention in the seventeenth century, refinements to microscope technology have increased its resolving power. Beyond the light microscope there are more sophisticated devices that have opened up new territories, including the transmission electron microscopes (TEM), the scanning electron microscope (SEM), and the scanning tunnelling microscope (STM).

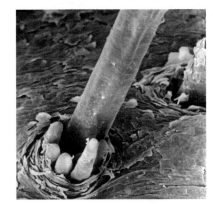

← **Left:**
Colored SEM of an eyelash hair
The base of the hair shaft can be seen emerging from the skin of the eyelid. Hairs grow from follicles in the underlying layer of skin (the dermis). The portion of the hair protruding from the skin is made up of dead tissue and the protein keratin. Eyelashes prevent foreign bodies from entering the eye.
Magnfication: unknown.

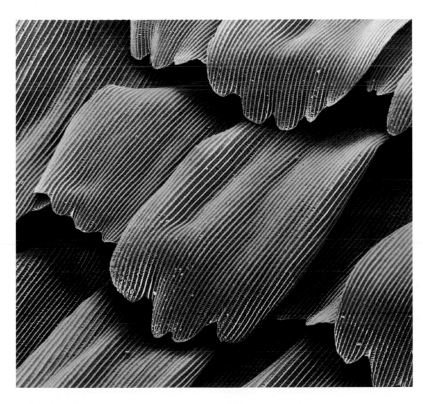

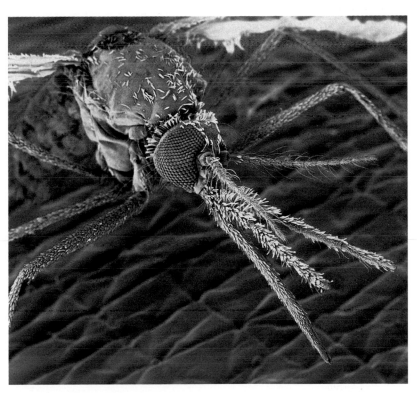

← **Facing opposite:**
Color Scanning Electron Micrograph (SEM) of red and white blood cells and platelets
Red blood cells have a characteristic disk shape. These large cells contain hemoglobin, a red pigment via which oxygen is transported around the body.
Magnification: unknown.

↑ **Above:**
Colored SEM of scales from the wing of a peacock butterfly
These scales have an intricate design and overlap like the tiles on the roof of a building. They allow heat and light to enter, and also help to prevent warmth from escaping from the butterfly. They may also be highly colored.
Magnification: x450 at 6x6cm size.

↑ **Above:**
Color SEM of a malaria mosquito
The blue compound eyes are seen at upper center of the image. Emerging from the head is a characteristic three-pronged fork made up of two mandipular palps and the proboscis. The proboscis is used by the female of the species to draw blood. Anopheles transmit malaria.
Magnification: x23 at 6x6cm size.

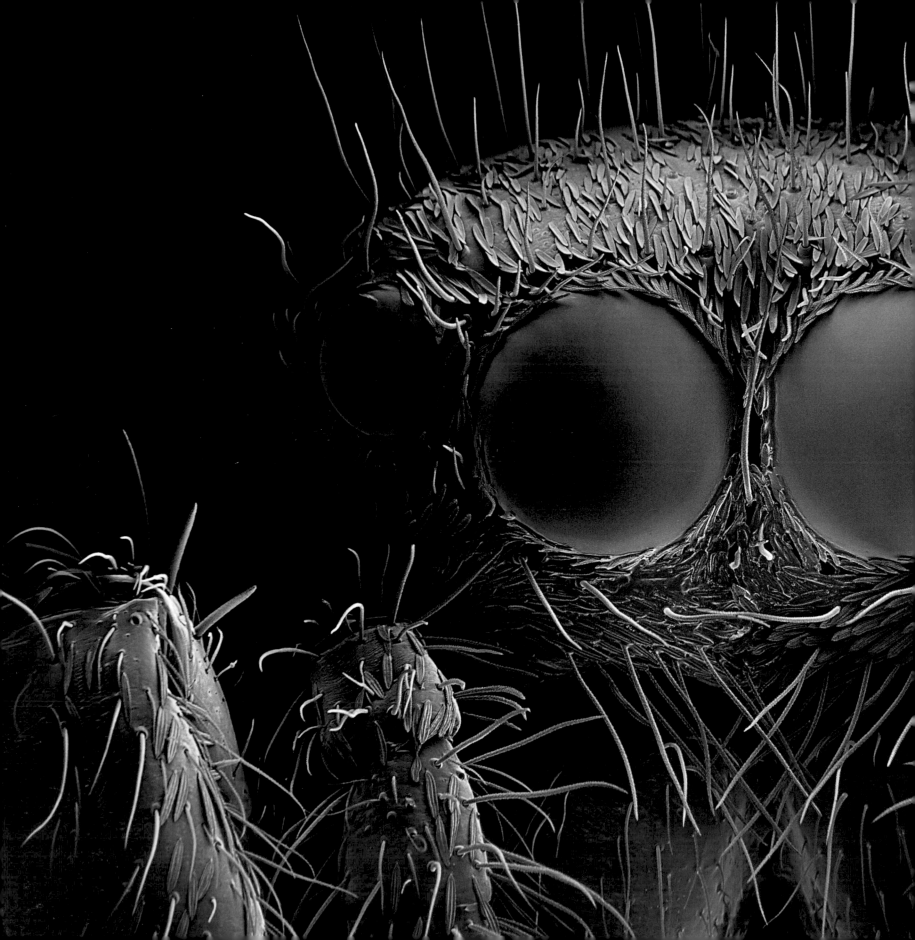

← **Left:**
Colored SEM of a jumping spider head
Jumping spiders are visual hunters which creep
up to their prey before leaping on them from
a few inches away. Four of the spider's eight
eyes can be seen here. They possess acute
vision and are able to move their eyes forward
and backward, up and down, and to either side,
and even rotate them.
Magnification: x35 at 5x7cm size,
or x60 at 4x5in.

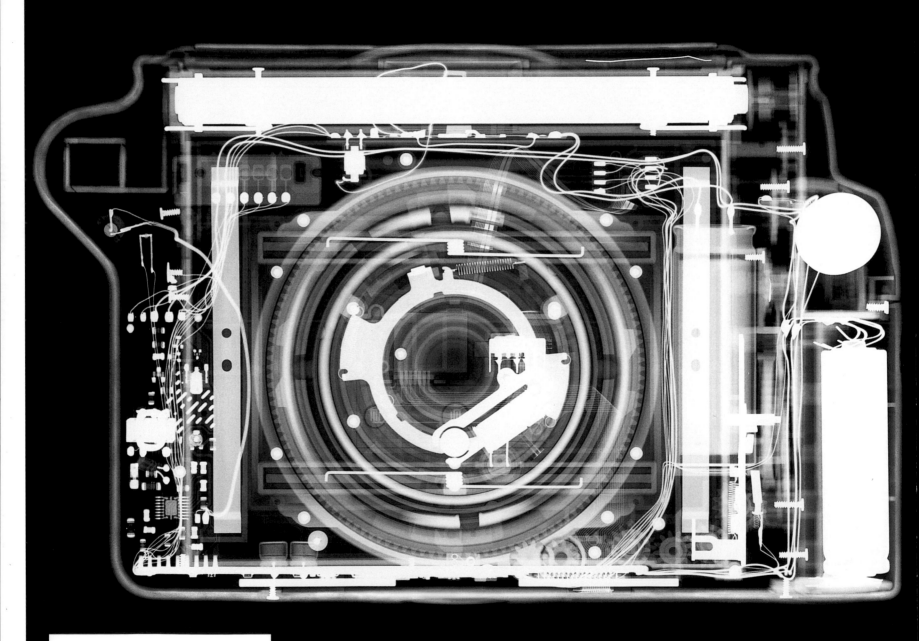

X-ray vision
In the hands of a skilled photographer, the X-Ray can have creative as well as medical applications. This image of a camera was produced by Peter Dazeley, who has utilized X-Ray techniques within his commercial and personal work. (Picture: Peter Dazeley)

X-ray specs

As with many of the world's most influential inventions, the X-ray was discovered while scientists were in pursuit of other investigations. Today, its many uses are invaluable to the way that we live.

A new kind of image

German scientist Wilhelm Conrad Röntgen discovered what he was to term "X-rays" (electromagnetic radiations with a shorter wavelength than light) during the course of experiments studying the passage of electricity through a tube containing a gas at low pressure. In 1895, he established that objects of varying thickness placed in the path of the rays showed variable transparency when recorded on a photographic plate.

He asked his wife to hold her hand over a photographic plate in the path of the rays and this produced an image of the bones of her hand and her ring. Röntgen had produced his first "röntgenogram" or X-ray—so-named because the nature of the rays was then unknown. Later, X-rays were shown to have the same electromagnetic nature as light, and to differ only in the higher frequency of their vibration. They can penetrate most tissue, but are absorbed by bone, and can be recorded on photographic film. This enables images of the internal structure of the body to be recorded, so that bone or joint defects, fractures, or foreign bodies can be detected. For many years, their main drawback was the potential for cell damage, but this has been almost entirely overcome by increased sensitivity of photographic and electronic detectors.

X-ray applications

The use of X-rays is not limited to medical research. They are widely used in security, and for testing for metal fatigue. There are also specialized assignments for which the technology is ideal. For example it was used to identify the mummified remains of Queen Nefertiti in Luxor's ancient royal burial ground, in the Valley of the Kings. Instead of having to remove mummies to a hospital for research to be carried out, new flat-screen X-ray technology permitted radiographers and scientists to construct an instant three-dimensional skeleton of the mummified body.

The digital X-rays revealed rare gold beads in the mummy's broken chest cavity, cast in a shape that was associated with royalty (including Nefertiti herself), and it was surmised that these had been broken loose in ancient times by tomb robbers as they ripped the jewelry from her body. Other discoveries made possible by X-ray images were confirmation that the pelvic anatomy was consistent with that of a female, and that the epiphyseal joints were fused, proving that the mummy was an adult. Spinal X-rays revealed lumber scoliosis. Most exciting of all was the fact that the visual information gave researchers the opportunity to reconstruct the face of Nefertiti to discover what she really looked like. In this way, X-ray technology offered scientists a means to travel into the past to glimpse a unique portrait.

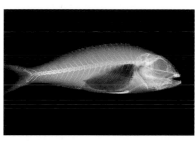

↑ **Above:**
Grouper fish
Peter Dazeley has been exploiting the ethereal appeal of the X-Ray image. Prints of these subjects have sold well to collectors. (Picture: Peter Dazeley)

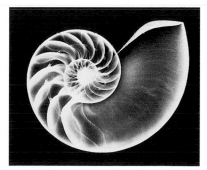

↑ **Above:**
Nautilus shell
Even ordinary items such as this nautilus shell become extraordinary items under the gaze of the X-Ray camera. (Picture: Peter Dazeley)

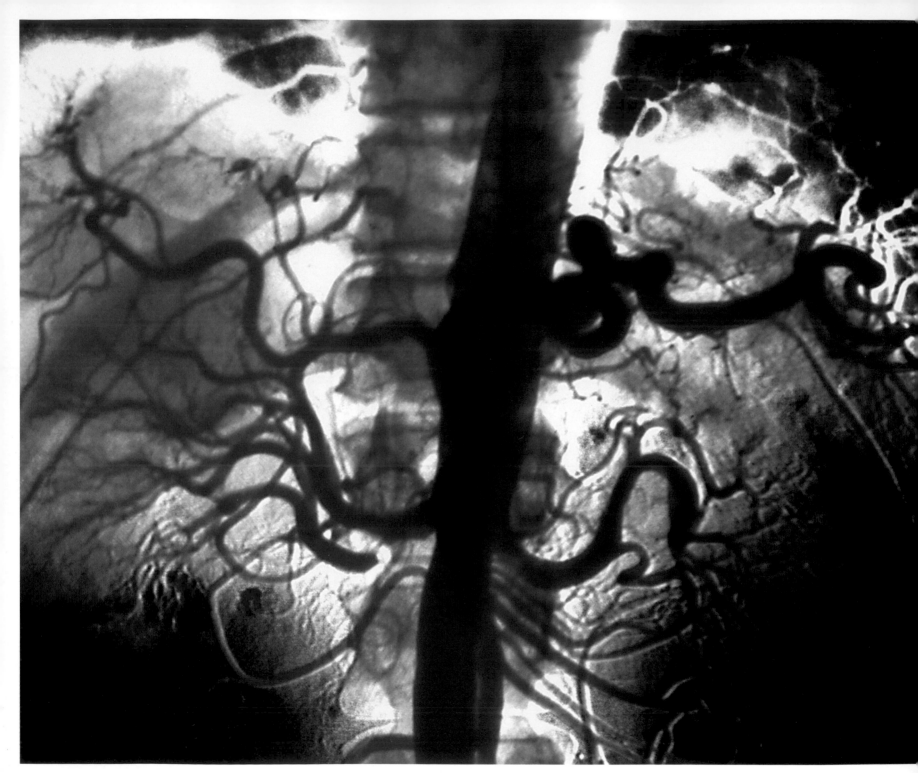

↑ **Above:**
Colored arteriograph (angiograph) of the abdominal arteries of a healthy person
Arteriography is an X-ray of an artery that has been outlined by prior injection of a radio-opaque contrast medium. Here the arteries are shown supplying blood to the kidneys, spleen, and liver. (Picture: CNRI/Science Photo Library)

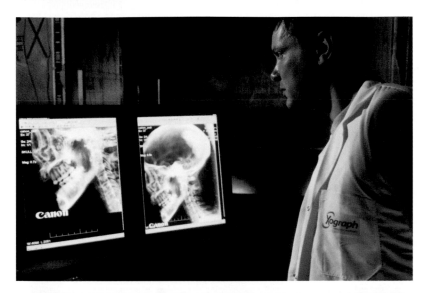

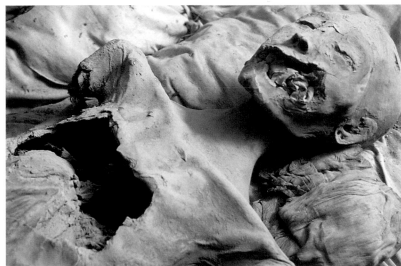

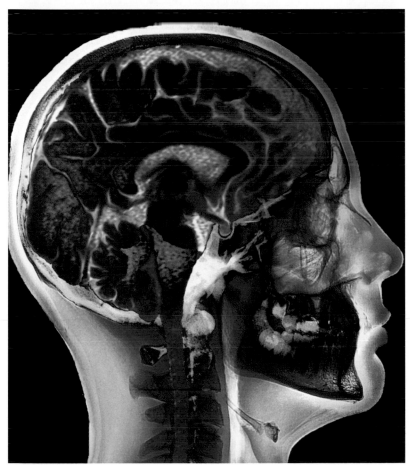

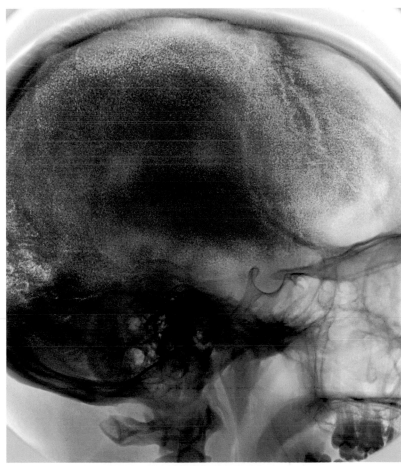

↑ **Top left:**
The Canon CXDI-31
This, the world's first portable digital radiography system, was used to identify the mummified remains of Queen Nefertiti in Luxor. It was able to produce instant pictures of the mummy's skeletal structure, displaying images on twin diagnostic monitors, enabling the forensic team to perform advanced image manipulation and interpretation. (Picture: The Discovery Channel)

↑ **Above:**
Colored X-ray of a human skull (side view)
All parts of the skull are clearly visible and highlighted by artificial coloring. (Picture: Science Photo Library)

↑ **Top right:**
Queen Nefertiti
The mummy was in a delicate condition, but the use of X-rays allowed it to be examined in detail without causing any damage. (Picture: The Discovery Channel)

↑ **Above:**
Colored X-ray of a human skull (side view)
The bones of the cranium are fused to encase and protect the brain. The frontal bone of the cranium forms the forehead or brow above the eye sockets. The facial skeleton comprises the nasal, cheek, and upper jawbones. (Picture: Science Photo Library/Du Cane Medical Imaging)

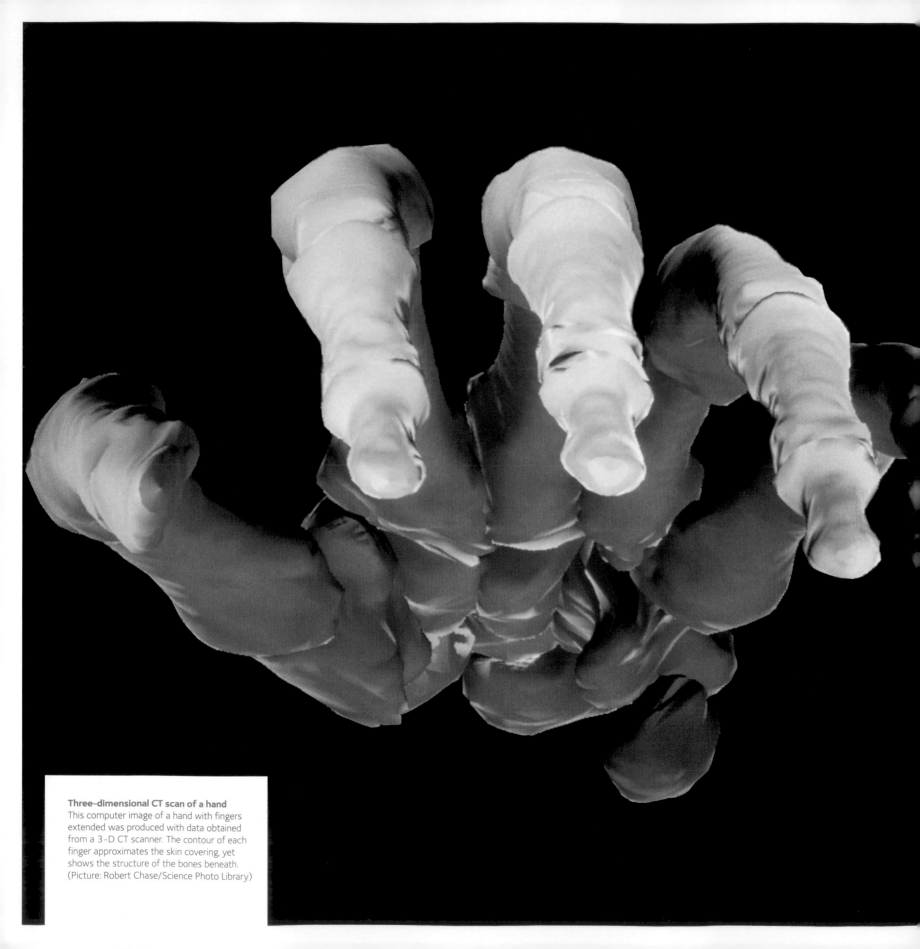

Three-dimensional CT scan of a hand
This computer image of a hand with fingers
extended was produced with data obtained
from a 3-D CT scanner. The contour of each
finger approximates the skin covering, yet
shows the structure of the bones beneath.
(Picture: Robert Chase/Science Photo Library)

Computed tomography

While traditional X-rays show bones very clearly, they are poor at reproducing soft tissue. CT scans utilize a thin X-ray beam to scan around a subject—effectively "looking" at it from many different angles—to produce a three-dimensional view of the body.

Invented independently in 1972 by Nobel Peace prizewinner Godfrey Hounsfield and physicist Allan Cormack of Tufts University, Massachusetts, the Computed Tomography (CT) scan utilizes a thin X-ray beam to scan around a subject, effectively "looking" at it from different angles. A computer reconstructs the streams of signals to create an image slice or "tomogram", revealing a cross-section of body tissue and organs. Image slices are combined to produce a three-dimensional view of the body.

CT scanning involves little exposure to radiation and provides detailed information on head injuries, brain tumors, and other brain diseases. It is also capable of showing bone, soft tissue, and blood vessels in the same image. The scanner itself is a large device with an aperture in the center. The patient lies still on a table that can move up or down, and slide in and out of the aperture. An X-ray tube, on a rotating gantry, revolves around the patient's body to produce the images by emitting and recording beams from as many as a thousand points during the revolution.

Unlike conventional X-rays, which produce pictures of the "shadows" cast by body structures of different density, CT scanning works by passing numerous X-ray beams through a subject—for example the skull and brain—at different angles, while special sensors measure the amount of radiation absorbed by different tissues. A special computer program uses the differences in X-ray absorption to form the "slices" through the body.

The first CT scanner developed by Hounsfield in his lab at EMI took several hours to acquire the raw data for a slice, and several days to reconstruct a single image. Now, a chest can be scanned in five to ten seconds.

Magnetic Resonance Imaging (MRI)

An MRI scan is a radiology technique that uses hydrogen atoms to visualize soft tissue in the body. A brief radio signal is sent through the body, knocking the atoms out of alignment. As the atoms flip back, they emit radio waves that are detected and analyzed by a computer. Different tissue requires different signal strengths, depending on how much hydrogen is present as water or fats. In a similar way to the CT scan, the signals are combined to form a "slice" image through the body, and a number of these can produce a three-dimensional view.

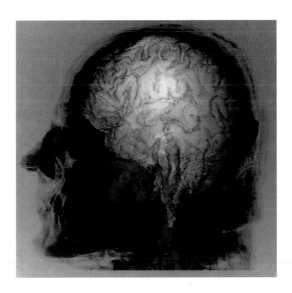

↑ **Above:**
Three-dimensional scan of the brain
This scan uses Computed Tomography (CT) and Magnetic Resonance Imaging (MRI). The head is in profile, and bones of the face are colored blue (at left), with the jawbone and neck vertebrae at lower center. Scan data of the cranium of the skull have been excluded, to expose the deeper left side of the brain (orange). CT scanning (X-rays) and MRI scanning (magnetic field and radio waves) create "slices" through the body. These were recombined to form this 3-D image. (Picture: Alexander Tsiaras/Science Photo Library)

An insider's view

Ultrasound uses inaudible, high-pitched sound waves to "look" inside the body. The technology for seeing and recording images of an embryo, for example, have revolutionized how we relate to the unborn child.

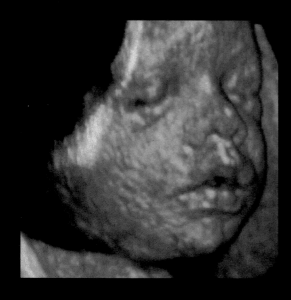

↑ Above:
Fetal ultrasound
Three-dimensional ultrasound scan of the face of a 30 week old fetus. The image was produced by a Kretz system, which enables fetal disorders such as harelip and spina bifida to be diagnosed before birth. (Picture: BSIP/Kretz Technik/Science Photo Library)

Here's looking at you, kid

The ultrasound probe receives signals that echo from the boundaries between soft tissue and fluids, and converts them into an electronic signal that is displayed on a computer screen. In a typical ultrasound scan, millions of pulses and echoes are sent and received each second, and the probe can be moved along the surface of the body and angled to obtain various views. The result is a two-dimensional image of a three-dimensional object such as a fetus or a specific organ. An alternative device, the Doppler ultrasound, measures the frequency of the echoes that it receives to calculate how fast an object is moving, and is used to measure the rate of blood flow through the heart and other major arteries.

The most dramatic advance in this area in recent years is the development of 3-D ultrasound imaging. While traditional ultrasound uses high-frequency sound waves to bounce off the surfaces and structures of the fetus or organ, a 3-D scan is created by moving the probe across the body, or by rotating inserted probes, to acquire a number of two-dimensional images that are then combined by specialized software to form a 3-D view.

Applications

Conventional ultrasound is now a common way of assessing the health of an embryo, its growth rate, its position in the womb, and the amount of amniotic fluid cushioning the baby. It can also identify tumors of the ovary and breast, examine the heart to reveal abnormal structures or functions, measure the blood flow through the heart, the kidneys, and major blood vessels, spot kidney stones and gallstones, and make an early diagnosis of prostate cancer.

3-D ultrasound imaging is commonly used to examine suspected tumors, to look for masses in the colon and rectum, and to detect breast lesions. It also provides a much clearer picture of a growing embryo, allowing observation of the face and limbs and revealing abnormalities of the brain, or spina bifida. On the commercial front, some surgeries are now offering pregnant patients the choice, for a fee, of having a 3D ultrasound scan of their unborn child so that they can visualize its facial characteristics months before it's actually born.

CONQUEST HOSPITAL :885008
SSD-1700 :

23/24[1]
34Hz

R12 G71 C5 A1

3:N.T.

Inside story
This is the ultrasound image that many
parents-in-waiting are used to seeing.
The head of the unborn infant can be clearly
seen in this picture. (Picture: Luke Herriott
and Becky Willis)

Looking inward

Endoscopy examines the body with minimal invasion. Making use of modern techniques and instruments, pioneers are using endoscopes to transform our knowledge of the human body.

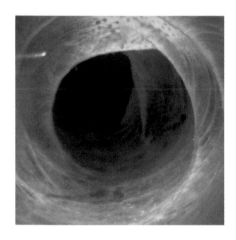

↑ Above:
Interior of the human small intestine
Circular folds are visible along the length of this section. (Picture: Manfred Kage/Science Photo Library)

→ Right:
Interior of human arteries
Two main channels are visible. The network of blood vessels (arteries and veins) is lined internally by a single layer of cells. (Picture: Manfred Kage/Science Photo Library)

Pioneered in the early 1900s and still in constant development today, the endoscope has enabled us to see parts of the human body that were previously unreachable.

There are two main types of endoscope: the rigid and the flexible. The rigid endosocope was the first to be invented, and is a metal tube that is inserted into the body. A light is shone down the tube, and the image is transmitted back for examination, via relay lenses, on to a computer. The invention of fiber optics in the 1960s led to the development of flexible endoscopes, and these can follow the twists of the digestive system, to examine the colon (colonoscopy), and the stomach and duodenum (gastroscopy). Modern endoscopes are fitted with tiny instruments that can allow small surgical procedures to be performed or tissue samples to be obtained.

The latest endoscopes have many refinements, such as a wide-angle field of view that can give 100° coverage, and a higher number—usually many thousands —of fibers bundled very close together to give improved resolution. The light itself is bundled in with the fibers, and the tip of the endoscope may be as small as 0.2mm.

Applications
Endoscopy allows the physician a non-invasive view inside the body to discover the reason for problems, such as difficulties with swallowing, nausea, vomiting, reflux, bleeding, indigestion, abdominal pain, chest pain, or to examine the development of an unborn child.

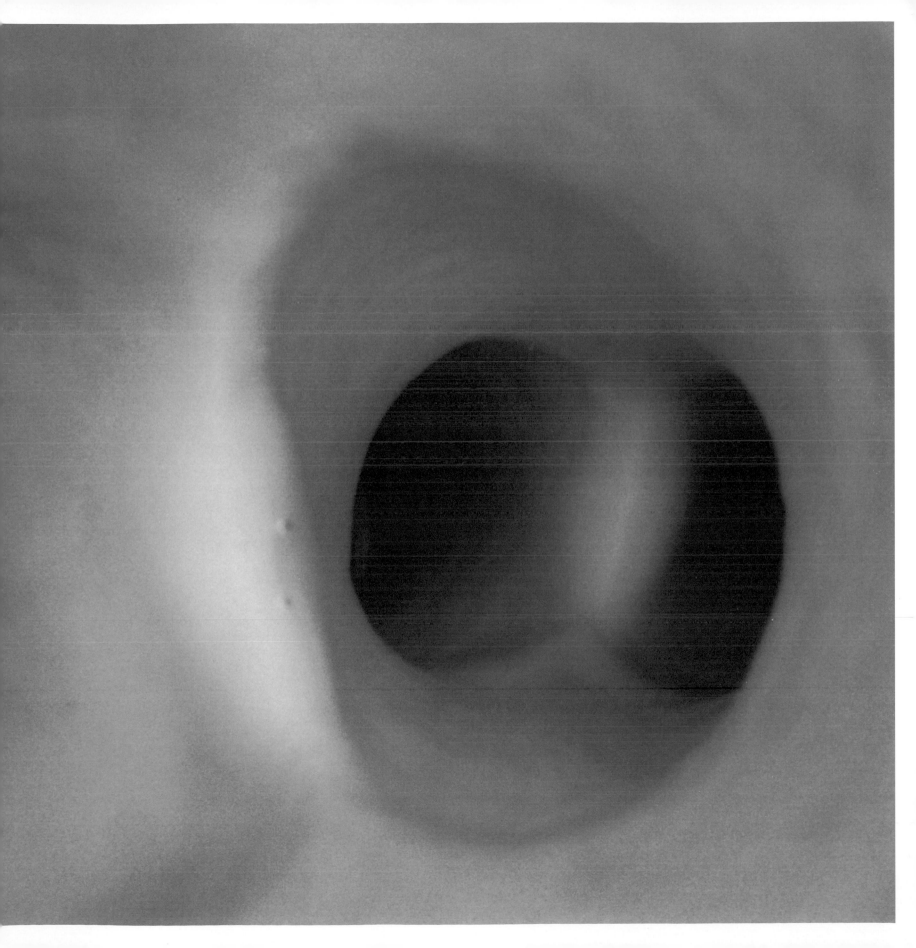

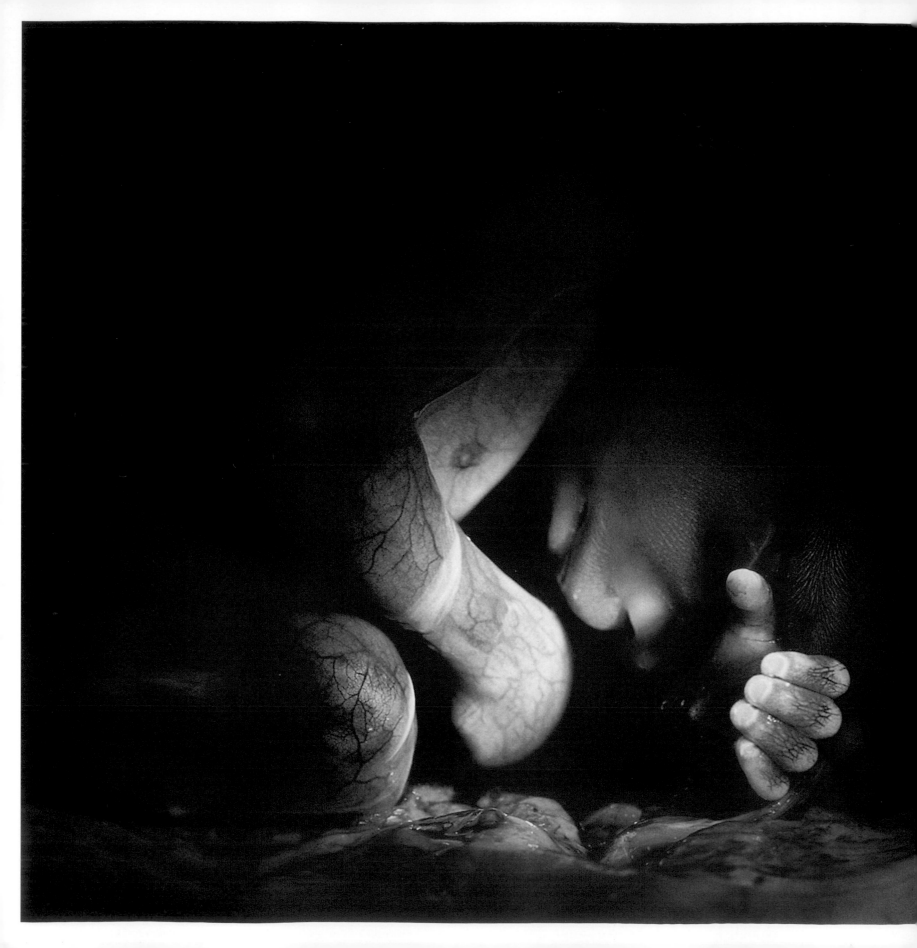

Lennart Nilsson and the unborn child

Lennart Nilsson is renowned for his pioneering work in medical photography. In association with researchers, and with the help of advanced, specially designed equipment, he has documented almost every aspect of the human body, right down to cellular level. He has devoted special attention to capturing the creation of a human being, from conception to birth.

The cutting-edge technology behind Nilsson's image-making is breath-taking. He makes use of two tiny, wide angle endoscopes—just 0.6 and 0.8 millimeters in size, each of which feature a 0.5-millimeter lens, giving Nilsson a 100° view of the embryo. Nilsson, who works closely with researchers in Japan, and German optic company, Storz, to refine his endoscopes, has recently ordered one just 0.3 millimeters in size. A Betacam video recorder records the high-resolution images, guaranteeing fine reproduction. In order to illuminate his subjects, Nilsson uses a fiber-optic light, made up of thousands of minuscule fibers, one tightly inserted alongside the endoscope, and, when space allows, another from the side for an enhanced perspective. One might imagine his techniques are necessarily invasive, but this is purposely limited—Nilsson's endoscope is inserted, via a laparoscropy, through the uterine wall, which is a safe and very effective method.

While Nilsson has been awarded numerous prizes and honorary degrees, arguably his most far-reaching achievement is to have NASA's unmanned spacecraft Voyager I and Voyager II both carry photographs from his bestselling 1965 book *A Child is Born* on their journeys through our solar system and out into the universe.

← **Left:**
The unborn child
This awe-inspiring image, taken from Nilsson's *A Child Is Born*, is of a relatively mature fetus in the womb, captured apparently curled up sleeping, unbothered by the camera or the light. (Picture: Lennart Nilsson)

← **Left:**
Say hello, wave goodbye
Endoscope image of the human fetus
in the womb after approximately three
months' development, showing the extent of
development of the hands. The fetal skin is
very thin and transparent at this stage, and
allows the bones of the fingers and blood
vessels of the hands to be seen.
(Picture: Edelmann/Science Photo Library)

the farthest

→The early years →Satellites →Eye on the universe
→Calling Earth →Mission to Mars

The invention of photography was a crucial breakthrough for astronomers. It enabled them to record detailed images that could be used for research and to support their findings. The subsequent development of space travel has opened up exciting possibilities, greatly increasing our understanding of the universe, and our relative insignificance within it.

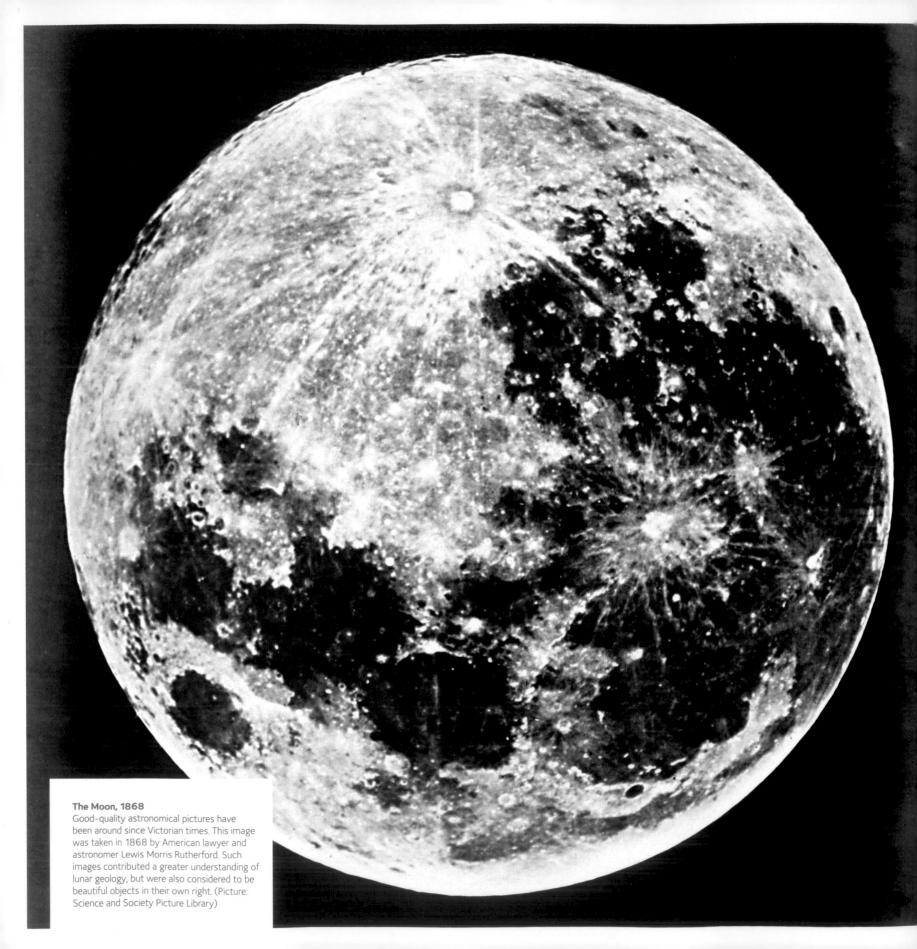

The Moon, 1868
Good-quality astronomical pictures have been around since Victorian times. This image was taken in 1868 by American lawyer and astronomer Lewis Morris Rutherford. Such images contributed a greater understanding of lunar geology, but were also considered to be beautiful objects in their own right. (Picture: Science and Society Picture Library)

The early years

Photography brought the promise of detailed, empirical records of planetary observations that would be far superior to hand-drawn references. The increased verisimilitude excited many leading nineteenth-century astronomers, among them François Arago.

In 1839, Arago addressed the members of the Académie des Sciences on Daguerre's discovery of the first workable photographic process. He announced that since Daguerre's process was "more sensitive to light than any other [process]," it was hoped that photographic maps could be made of the Moon.

Daguerre himself made what are believed to be the first photographic images of the Moon, although they were, according to contemporary accounts, "faint and lacking in detail". More successful were early American Daguerreotypes—one of the best was produced by Samuel D. Humphrey in 1849. His effort was outshone, however, by the lunar Daguerreotypes made by Whipple and Bond early in 1851 at the Harvard Observatory. One of these, exhibited at the Great International Exhibition of the same year, became a celebrated object in its own right, and it was praised for its clarity and detail, which were far superior to anything that had gone before. In the same year Whipple and Bond also managed to photograph two of Jupiter's bands.

In 1856 photographer and astronomer Warren De la Rue produced images of Mars and, two years later, announced that he had pictures of Jupiter, Saturn, and the double star Alpha geminorum as well. It was also De la Rue who tackled one of the main problems facing the early pioneers—the lack of sensitivity of the photographic processes available at the time.

The long exposures that were required meant that the motion of the moon and stars would be recorded as blur unless the telescope was guided by hand to exactly match their progress—no easy feat. By 1857, however, De la Rue had developed a telescope with a primitive automated guiding mechanism, and he used this to produce a series of images of the Moon that he sent for perusal to Henry Fox Talbot. Fox Talbot thanked him for the "beautiful photographs," but noted that they had not yet been perfected.

The photographic exploration of the solar system continued as Whipple and James Wallace Black made their first photographs of Saturn and the Pleiades in 1857, while the advent of the dry gelatin plate in the early 1870s improved emulsion sensitivity, and allowed Lewis Morris Rutherford to produce an impressive series of albumen silver prints of the Moon, which were shown to the Académie des Sciences in 1872. Praised for their aesthetic beauty, they were also recognized as having contributed to a greater understanding of lunar geology.

Early landmarks in astronomical photography

- **In 1883** Dr. Ainslee A. Common made a 30-minute exposure of the great Orion nebula, revealing details unseen in the largest telescopes. This image finally proved that photography was the superior medium for recording visual observations.

- **From 1896–1910** Pierre Puiseux and Charles Le Morvan produced highly detailed images of the Moon's face, which remained among the most important reference documents for the study of lunar geography for many decades.

- **In 1924** W. H. Wright and Robert J. Trumpler photographed the surface of Mars with the 36-inch (91 cm) telescope at the Lick Observatory, California, using plates sensitized for limited sections of the spectrum. The images on the infrared and red-sensitive plates clearly showed the surface topography.

- **Edwin Powell Hubble (1889–1953)** took pictures of deep space in the early twentieth century, showing that our galaxy was not alone. With Milton Humason he continued this research during the 1930s and 1940s, greatly expanding our knowledge of previously uncharted areas of the universe.

Satellites

Satellites come in diverse forms with a range of functions, and they can take up fixed geostationary positions or form polar orbits. Some, such as Telstar and Intelsat, act as a communications aid, allowing data conversations to be relayed around the world.

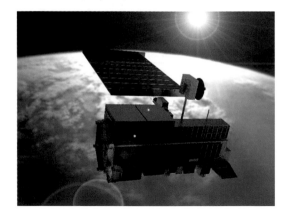

↑ **Above:**
Aqua satellite
NASA's Aqua satellite can provide detailed information on a daily basis, thanks to its Atmospheric Infrared Sounder (AIRS) and Advanced Microwave Sounding instruments. The detectors can provide a three-dimensional view of the Earth's weather, even when there are heavy clouds hiding the surface of the planet. (Picture: NASA)

A communications satellite is equipped with up to thousands of transponders: radios that receive a conversation at one frequency and then amplify it and transmit it back to Earth on another. Similar satellites broadcast television signals, too.

Other satellites are designed to perform scientific missions, one of the most famous being the Hubble Space Telescope. Others still are geared toward life on our own planet, and perform a vital role in explaining weather systems, aiding our understanding of why such phenomena as droughts and flooding occur, and providing warnings of approaching storms. A typical example is Terra, launched in 1999. Part of NASA's Earth Observing System (EOS), this, and its sister craft Aqua, serve as space-based "remote sensors", enabling us to study Earth's temperature.

MODIS (the Moderate-resolution Imaging Spectroradiometer), another satellite, views every point on the globe in 36 discrete spectral bands, and tracks a wide array of Earth's vital signs. It monitors large-scale changes in the biosphere to yield insights into the carbon cycle, measuring the photosynthetic activity of land and marine plants to yield estimates of how much of the greenhouse gas is being absorbed and used in plant productivity. As well as gauging the extent of seasonal changes, MODIS also serves as an early warning system for volcanic eruptions, extreme weather, and wildfires.

The Multi-angle Imaging Spectro-Radiometer (MISR) on Terra is like no instrument in space. Viewing the Earth at nine widely spaced angles, MISR provides ongoing global coverage with high spatial detail. Its imagery is calibrated to provide measurements of the brightness, contrast, and color of reflected sunlight. MISR also provides climatologists with essential information on the partitioning of energy and carbon between the land surface and the atmosphere.

With its visible, infrared, and microwave detectors, the AIRS experiment provides a three-dimensional look at Earth's weather. With over 2,400 channels sensing the atmosphere, the system creates a three-dimensional map of atmospheric temperature, so that information about clouds, greenhouse gases and other phenomena can be recorded.

With the help of the information garnered by these satellites, scientists will be able to better understand how global ecosystems work and how they respond to and affect global environmental change.

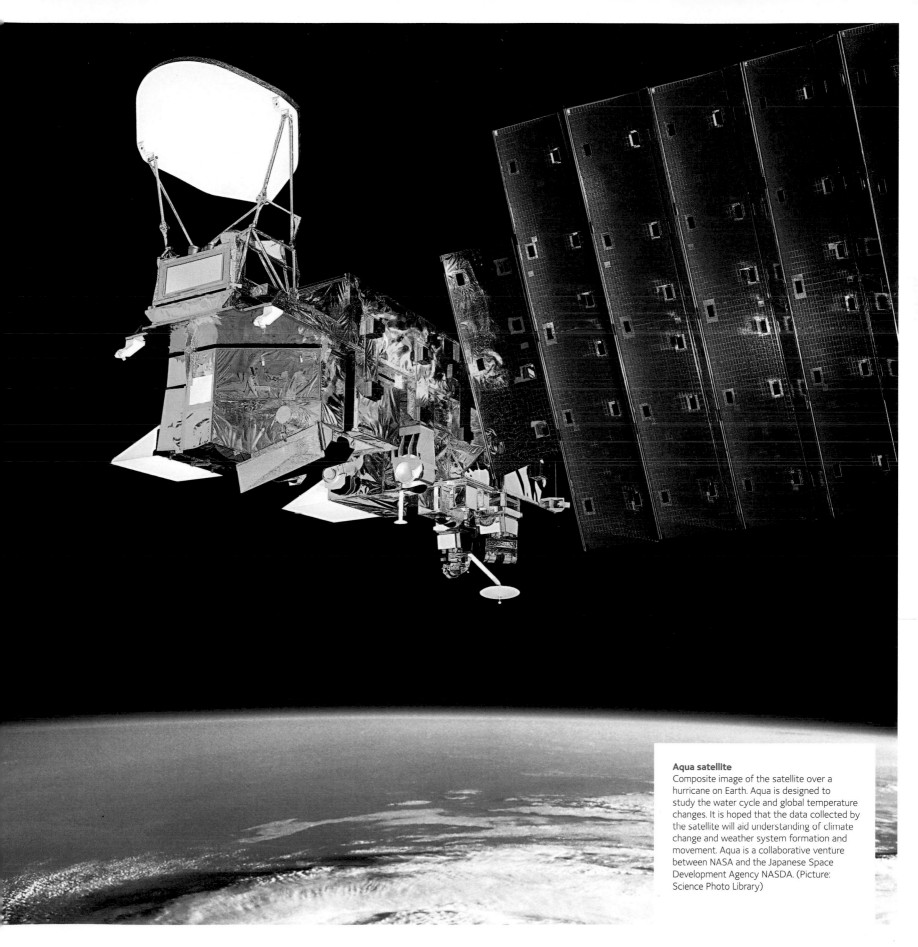

Aqua satellite
Composite image of the satellite over a hurricane on Earth. Aqua is designed to study the water cycle and global temperature changes. It is hoped that the data collected by the satellite will aid understanding of climate change and weather system formation and movement. Aqua is a collaborative venture between NASA and the Japanese Space Development Agency NASDA. (Picture: Science Photo Library)

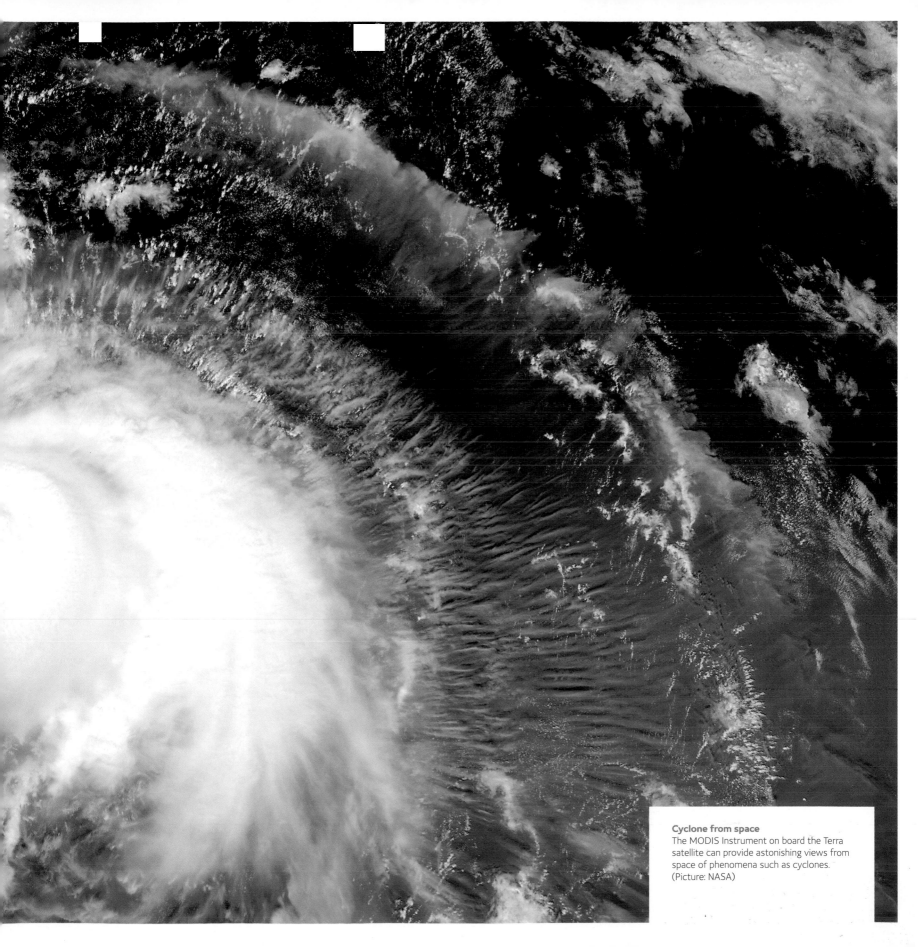

Cyclone from space
The MODIS Instrument on board the Terra satellite can provide astonishing views from space of phenomena such as cyclones.
(Picture: NASA)

Eye on the universe

Earth-based telescopes are increasingly sophisticated, but they will always suffer from the fact that the light they receive has to pass through the atmosphere before reaching them.

The wonderful Hubble

Not only is the light degraded by clouds, weather systems, and light pollution, but the atmosphere itself is a "boiling" place, where dust, rising currents of warm air, falling currents of cold air, and water vapor can be found. A telescope in space would circumvent the problems these factors present.

The first proposal for such a telescope came in 1946 from a scientist named Dr. Lyman Spitzer, even though at that time no-one had yet launched a rocket into outer space. However, as the space program developed and satellite technology evolved, the idea started to become more practical, and Spitzer pursued his idea by lobbying NASA and Congress in the US.

Eventually the European Space Agency and NASA began developing the space telescope in 1975. Years of development followed and, in 1983, the project was named the Hubble Space Telescope (HST) after the renowned American astronomer Edwin Hubble, whose observations in the earlier years of the century had helped to support the theory of the Big Bang.

It was seven years before the HST was launched, being deployed by the space shuttle in 1990. The anticipation was immense, with scientists promising that the telescope would be 50 times more sensitive than its ground-based equivalents, but, disappointingly, it was quickly discovered that it was impossible to focus the device.

← **Left:**
The Omega or Swan Nebula
Photograph by Hubble's Advanced Camera for Surveys. This updated instrument featured a tenfold increase in efficiency, which is allowing the telescope to see some of the faintest objects ever recorded. (Picture: NASA/STSci)

A primary mirror had been ground to the wrong shape and, although the defect was less than one-fiftieth the size of a human hair, it caused the HST to suffer spherical aberration and produce fuzzy images.

The solution was COSTAR (Corrective Optics Space Telescope Axial Replacement), which consisted of several small mirrors that would intercept the beam from the flawed mirror, correct for the defect, and then relay the corrected beam to the scientific instruments at the focus of the mirror. The delicate installation operation was successful, and the quality of the images received vastly improved.

Inside Hubble

Hubble is basically a traditional telescope, being a long tube that is open at one end. The distribution of the light inside the device is controlled by mirrors that are coated with layers of pure aluminum 3,000,000ths-of-an-inch (76,200,000ths of a millimeter) thick and magnesium fluoride 1,000,000th-of-an-inch (25,400,000th of a millimeter) thick.

Light enters the telescope through the opening and bounces off the primary mirror to a secondary mirror, which then reflects the light through a hole in the center of the first one to a focal point behind it, where smaller, fully reflective pick-off mirrors distribute the light to the various scientific instruments. Each of the five mirrors has a special function to perform, and they have been updated throughout Hubble's lifetime. Each replacement instrument has come with inbuilt corrective optics to take account of the original mirror's defect, and COSTAR is now no longer required.

The instruments are capable of discerning visible, ultraviolet, and infrared light and monitoring each of these wavelengths allows different properties of objects in the universe to be studied. Images are captured digitally, stored in on-board computers, and subsequently relayed to Earth.

Color images

Hubble doesn't use color film: rather, its cameras record images through the use of special electronic detectors, and these detectors work not in color, but in shades of black and white. Finished color images are combinations of two or more black-and-white exposures to which color has been added during image processing. The colors in Hubble images aren't always what the human eye would see if we were able to view the imaged objects from a spacecraft, but is instead often used as a scientific tool, perhaps to enhance an object's detail or to visualize what ordinarily the human eye could never see.

Light from astronomical objects comes in a wide range of colors, each corresponding to a particular kind of electromagnetic wave. Hubble can detect all the visible wavelengths of light, plus many more that are invisible to the human eye (such as ultraviolet and infrared light). Astronomical objects often change in appearance in these different wavelengths. To record what an object looks like at a certain wavelength, Hubble uses filters that allow through only a range of light wavelengths. Once the unwanted light has been filtered out, the remaining light is recorded. The many filters allow it to record images in a variety of light wavelengths, allowing scientists to study "invisible" features of objects—those visible only in ultraviolet and infrared wavelengths.

Many full-color Hubble images are a combination of three separate exposures—in red, green, and blue light. When mixed together, these can simulate almost any color of light that is visible to human eyes. The same principle used to create color in televisions, computer monitors, and video cameras.

Limitations

The HST is always pointed away from the Sun, because the intense heat and light would fry its sensitive instruments. This also means that Mercury can't be observed, and Venus and the Moon only with very specific conditions, because they are too close to the Sun. Certain stars are also too bright for Hubble to handle.

The orbit of the HST also limits what can be seen, with Earth itself sometimes obstructing its view, and there are also periods during which the satellite passes through the Van Allen Radiation Belts where high background radiation interferes with the detectors of the scientific instruments, and makes observation impossible.

The future

When Hubble was launched it was scheduled to have a 20-year lifespan, and plans are already in place for its successor. This will be called the James Webb Space Telescope, after a NASA administrator who was instrumental in furthering space science. A complementary follow-up to Hubble, it will observe in different wavelengths.

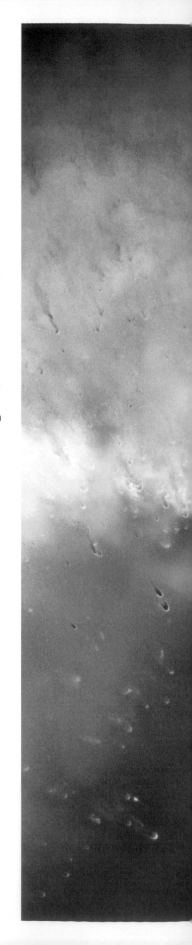

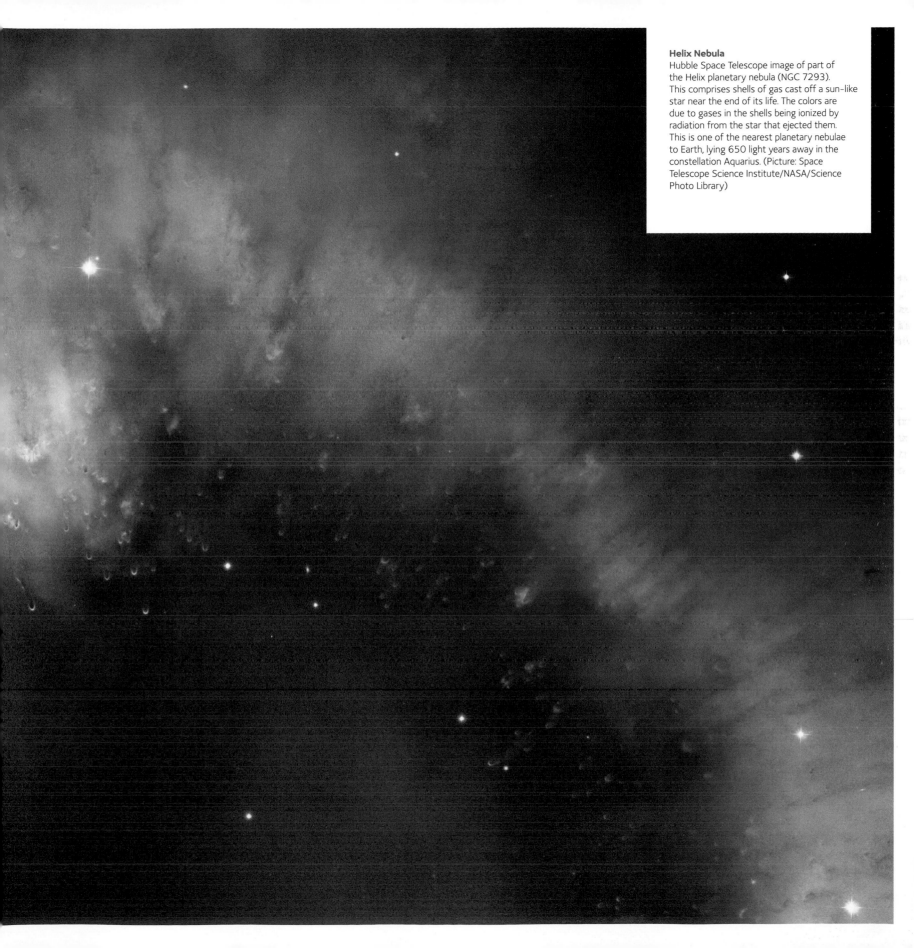

Helix Nebula
Hubble Space Telescope image of part of
the Helix planetary nebula (NGC 7293).
This comprises shells of gas cast off a sun-like
star near the end of its life. The colors are
due to gases in the shells being ionized by
radiation from the star that ejected them.
This is one of the nearest planetary nebulae
to Earth, lying 650 light years away in the
constellation Aquarius. (Picture: Space
Telescope Science Institute/NASA/Science
Photo Library)

Calling Earth

Since the Mercury missions of the early 1960s, astronauts have used hand-held cameras to photograph the Earth. To date, almost 500,000 exposures have been made in this way.

The International Space Station

The International Space Station (ISS) continues the hand-held tradition. The ISS is well suited for observations: its average altitude is 220 miles (354km) above the Earth, and its orbital inclination of 51.6° takes in most of the coastlines and heavily populated areas of the world.

The Destiny US Laboratory Module has a science window with a clear aperture 20 inches (50.8cm) in diameter, which is perpendicular to the Earth's surface most of the time. Its three panes of fused silica are of optical quality, and astronauts trained in scientific observation of geological, oceanographic, environmental, and meteorological phenomena scan for sites that are of particular interest. These include major deltas in South and East Asia, coral reefs, important cities, smog over industrial regions, areas that experience floods or droughts triggered by El Niño cycles, and alpine glaciers.

Hand-held photography fills a niche between aerial photography and imagery from satellite sensors, and complements these two with additional information. Dramatic events can be recorded with astronauts and scientists exchanging real-time information, while critical environmental regions will be photographed repeatedly over time, and can be compared with photographic records that can date back to Gemini and Skylab missions.

← Left:
World view
Earth's horizon and the blackness of space are featured in this image taken from a window on the International Space Station, by astronaut Edward T. Lu, Expedition Seven NASA ISS science officer and flight engineer. (Picture: NASA)

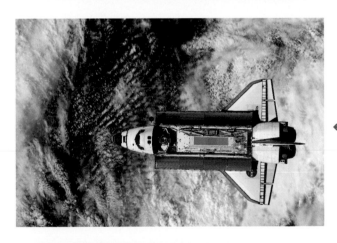

← Left:
Eruption on Mount Etna
The three-member crew of the Expedition Five mission on board the International Space Station was able to observe and photograph Mount Etna's spectacular eruption. This eruption was one of Etna's most vigorous, and was triggered by a series of earthquakes on October 27, 2002. (Picture NASA)

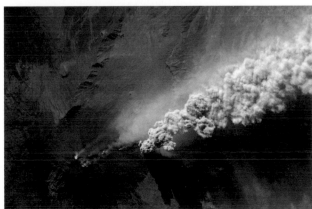

← Left:
Docking party
The Space Shuttle Atlantis prepares to dock with the International Space Station during the STS-110 mission. The STS-110 crewmembers are delivering the SO (S-zero) truss, which is visible in Atlantis' payload bay. This image was taken by an Expedition Four crewmember. (Picture: NASA)

← Left:
Earth from Endeavor
As seen through the window of the space shuttle Endeavor's aft flight deck, the International Space Station is contrasted against Earth's horizon. (Picture: NASA)

← Left:
Smoke and ash
An overhead look at the dying remains of the eruption of Mount Etna on the island of Sicily. This image was recorded by an Expedition Two crewmember with a digital still camera. (Picture: NASA)

ISS EarthKAM

A program based on shuttle missions was set up by NASA in 1994 under the title KidSat. Its operations were moved to the International Space Station (ISS) in 1998, and it has been renamed ISS EarthKAM.

EarthKAM allows middle school students in America to photograph and study Earth from space, by controlling a special digital camera mounted on a window in the ISS. The resulting images are then made available on the Internet for viewing and study by participating classrooms and the general public.

The photographs are taken by means of remote operations from the ground. Students target and request their desired images by tracking the orbit of

the ISS, referencing maps and atlases, and checking weather. Their requests are then collected and compiled at the University of California in San Diego. With help from representatives at Johnson Space Center in Houston, the compiled requests are loaded to a computer aboard the ISS. The computer records the requests and transmits them to the ISS EarthKAM digital camera, which takes the desired images and transfers them back to the computer. The images are then downloaded to the ISS EarthKAM computers on the ground, and within hours they are made available at www.earthkam.ucsd.edu for easy access.

↑ **Above:**
Dust clouds over the Sea of Japan. (Picture: 2002 Orbital Imaging Corporation/Science Photo Library)

→ **Above right:**
The Himalayas in China. (Picture: NASA)

→ **Right:**
Bangladesh and the Bay of Bengal. (Picture: NASA)

→ **Far right:**
Algeria. (Picture: NASA)

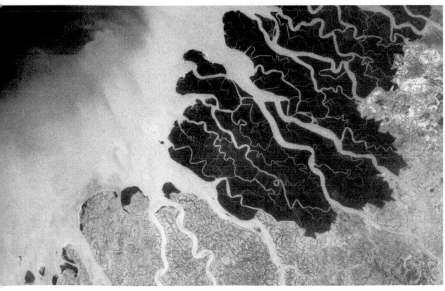

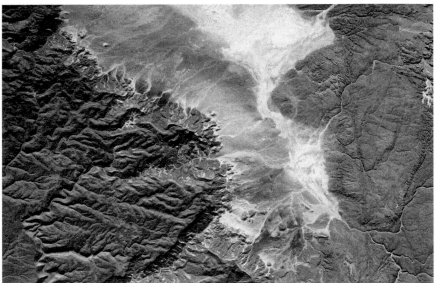

Missions to Mars

Unmanned missions that have been flown to planets nearest to Earth have made possible close observation and even, in some cases, pictures from the surface, greatly adding to human knowledge of these planets.

The first human artifact on Mars was deposited in 1971, when the USSR Mars 2 Orbiter/Soft Lander crash-landed on the planet as its rockets failed. No data was returned. A week later, Mars 3 made a successful landing, although it failed after relaying 20 seconds of video data to the orbiter. It did, however, continue to return other forms of data to Earth until the following year.

The US spacecraft Mariner 9 arrived at Mars on November 3, 1971, and was propelled into orbit on November 24. The first high-resolution images of the moons Phobos and Deimos were taken, and river- and channel-like features were observed. Mariner 9 remains in Martian orbit.

In 1972 the US spacecraft Pioneer 10 flew by Jupiter, returning over 500 pictures of the planet and its moons. It crossed the orbit boundary of Pluto on June 13, 1983, and has now left the solar system. Also in 1972 the USSR craft Venera 8 landed on Venus, and returned data for 50 minutes.

Following numerous missions by the USA and USSR to Jupiter, Saturn, and Mars, the launch of Mariner 10 in 1973 was scheduled to be the first time that a craft would have a dual planet mission, flying past Venus on its way to Mercury, which it passed three times, producing over 10,000 pictures in the process.

↓ **Below:**
In the round
The Mars Pathfinder Mission sent back this 360° image of the surface of Mars. (Picture: NASA)

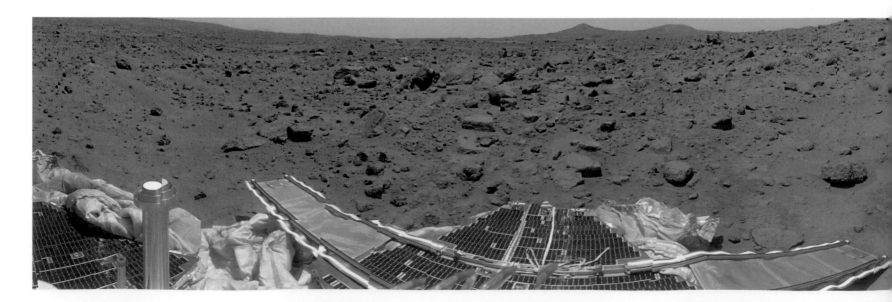

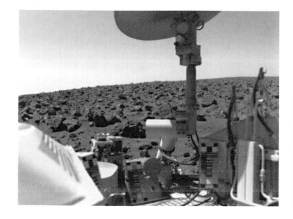 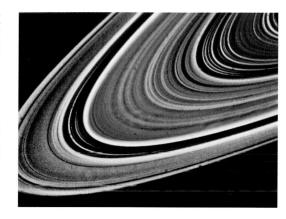

Subsequent missions to Mars

Launched in 1975, the Viking 1 and 2 missions were to provide the most complete view of Mars up to that point, their mission being to obtain high-resolution images of the Martian surface, and to look for signs of life. The Orbiters of the two craft imaged the entire surface of Mars, while the Viking Landers transmitted images of the surface, and took and analyzed samples. They also studied atmospheric composition and meteorology. After transmitting 1,400 images, they ended communications in 1980 and 1982.

Launched in 1977, Voyager 1 and 2 were scheduled to go past Jupiter and Saturn. Voyager 2 surpassed expectations and went on to Uranus and Neptune, too.

The mission was designed to take in a four-planet tour with minimum fuel and trip time. Through "gravity-assist" the flight time to Neptune was reduced from 30 years to 12. The pictorial results from the Voyager Imaging Science Subsystem (ISS) were exceptional, with images being received until 1990.

The future

With a manned landing on Mars a future possibility, attention is being devoted to mapping the planet's surface. Knowledge is being gained of what was once a very mysterious planet, much of it down to the quality of the photographs that have been obtained.

↑ **Above left:**
Utopia
The Mars Utopian Plain, photographed by Viking 2. (Picture: NASA)

↑ **Above middle:**
Ship shape
Voyager 1 in the Clean Room at NASA prior to launch. (Picture: NASA)

↑ **Above right:**
Filtering through
This Voyager 2 view, focusing on Saturn's C-ring was compiled from three separate images taken through ultraviolet, clear, and green filters. On August 23, 1981, when it acquired these frames, Voyager 2 was 1,700,000 miles (2,700,000 kilometers) from the planet. (Picture: NASA)

the brightest

→Shedding light on the Sun →Taking the eclipse

The Sun's inconceivable distance—some 93 million miles (150 million km) has not prevented scientists from attempting to photograph and analyze the star, and the result has been some incredible imagery that has, in recent years, helped to further our understanding of this source of all our energy.

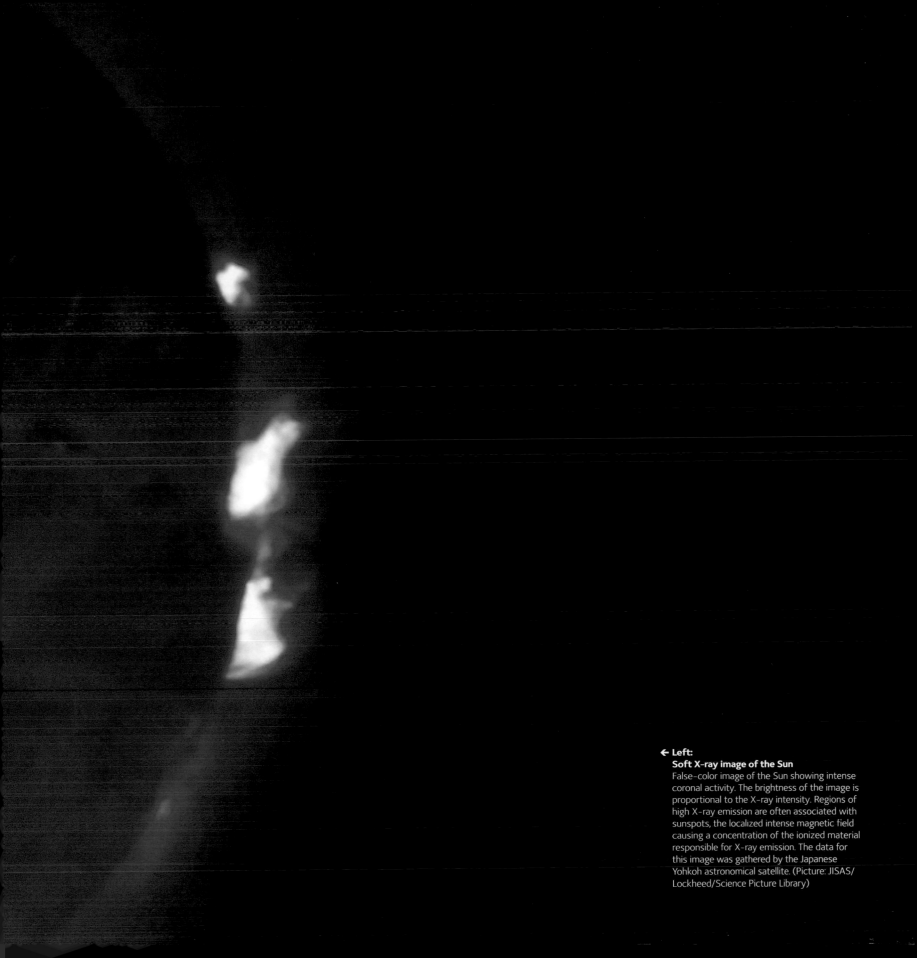

← **Left:**
Soft X-ray image of the Sun
False-color image of the Sun showing intense
coronal activity. The brightness of the image is
proportional to the X-ray intensity. Regions of
high X-ray emission are often associated with
sunspots, the localized intense magnetic field
causing a concentration of the ionized material
responsible for X-ray emission. The data for
this image was gathered by the Japanese
Yohkoh astronomical satellite. (Picture: JISAS/
Lockheed/Science Picture Library)

Shedding light on the Sun

Some space missions have recorded in extreme detail the surface of the Sun and the explosive nature of its corona.

The most recent missions to photograph the Sun have been the Japanese/US venture "Yohkoh", the "SOHO" (Solar and Heliospheric Observatory) project, and the "TRACE" (Transition Region and Coronal Explorer) satellite. To capture the amazing images on these missions, powerful telescopes are aimed directly toward the Sun. The highly specialized equipment is protected against potentially damaging effects by attenuating the brightness, and/or selecting just a particular part of the spectrum.

The Yohkoh craft

The satellite Yohkoh (Japanese for "sunbeam") is dedicated to high-energy observations of the Sun, specifically of flares and other coronal disturbances. Launched in 1991, it is a three-axis satellite in a slightly elliptical, low-Earth orbit. Each orbit takes around 96 minutes to complete, and Yohkoh spends 65 to 75 minutes of that time in sunlight. The craft's imaging instruments consist of hard and soft X-ray telescopes that have almost full-sun fields of view to avoid missing any flares. "Hard" and "soft" with respect to X-rays indicate high-energy (or more penetrating) and low-energy (or more readily absorbed material) X-rays.

In the extreme ultraviolet and soft X-ray range, the problem is that of the relative magnitudes of visible and EUV (Extreme Ultraviolet Light)/SXR (Soft X-Ray) radiation. Even with solar-blind optics and detectors, there is some response to visible wavelengths, and telescopes such as Yohkoh's SXT (Soft X-ray Telescope) and SOHO's EIT (Extreme Ultraviolet Imaging Telescope), compensate by featuring very thin aluminum sandwich filters to reject as much visible light as possible, while passing EUV or soft X-rays. Such instruments have an added filter protection.

The SOHO mission

The SOHO satellite is a joint project of the European Space Agency and NASA. It orbits between the Sun and the Earth, 92,000,000 miles (148,100,000km) from the Sun and approximately 1,000,000 miles (1,609,000km) from Earth, a distance that is still three times farther than the Moon.

Using a CCD (Charge-Coupled Device) to capture the coronagraph generates stories about UFOs. The truth is more mundane: the "funny looking spheroid" visible in several coronagraphs was the response of the instrument to a planet or bright star that is so dazzling it saturates the CCD camera, causing "bleeding" along a pixel row, leading to the "flying saucer" effect.

TRACE

TRACE is a small spacecraft with a single instrument —an UV/EUV multiplayer telescope similar to the EIT on SOHO—but with five times the spatial resolution and a smaller field of view. The craft allowed joint observations with SOHO during the rising phase of the solar cycle to a sunspot maximum. The two satellites provide complementary observations, and the opportunity to obtain simultaneous digital measurements of all the temperature regimes of the solar atmosphere.

→ **Solar corona**
Ultraviolet SOHO (Solar and Heliospheric Observatory) satellite image of the corona (haze) around the Sun. The corona, the Sun's outer atmosphere, is seen at three ultraviolet wavelengths, showing areas at: 1,000,000° (blue), 1,500,000° (green), and 2,000,000° C (red). This image is from SOHO's Extreme Ultraviolet Imaging Telescope (EIT) in May 1998, as the Sun neared the solar maximum in 2000. (Picture: NASA/Science Photo Library)

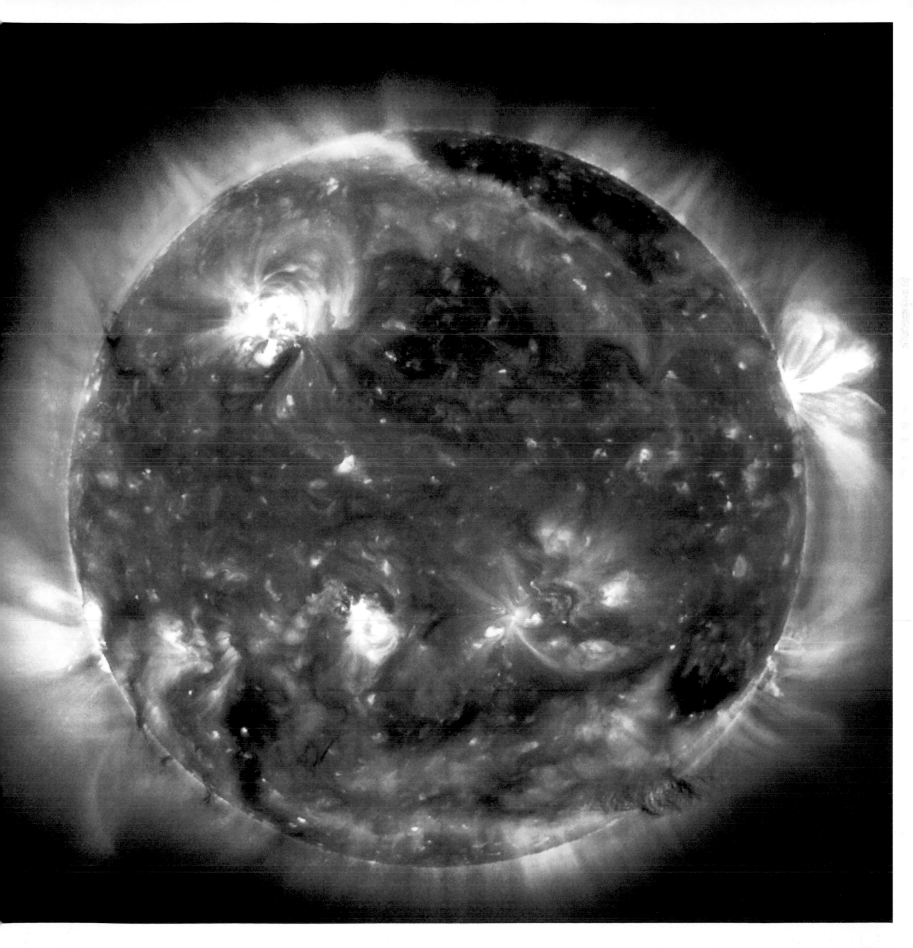

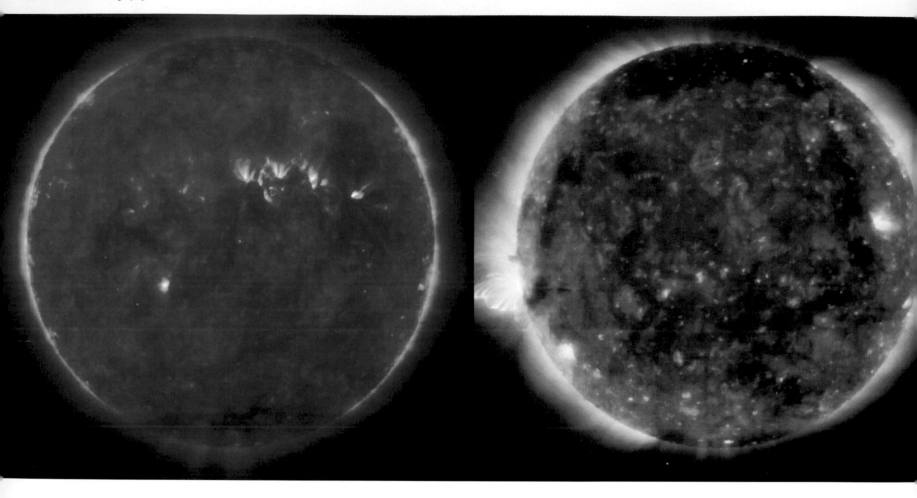

Ultraviolet imaging

The EIT telescope is an extreme ultraviolet-imaging telescope, and all its images are produced by extreme ultraviolet (EUV) light from the Sun. In the electromagnetic spectrum, this falls between ultraviolet light and X-ray light, and is not directly visible to our eyes. Just as the human eye is capable of discriminating different colors in the visible, so EIT's four bandpasses discriminate among four "colors" in the extreme ultraviolet. In addition, each color table is constructed to bring out typical features of its typical wavelength. Just as in the visible spectrum, red is the longest wavelength and blue is the shortest, with yellow and green in between.

The main scientific objective of the EIT telescope is to study the evolution of coronal structures over a range of spatial and temporal scales and temperatures.

Near disaster

The SOHO mission almost came to a premature end in June 1998, following an anomaly on board that caused the spacecraft to lose its orientation. Altitude analysis led to the conclusion that SOHO went into a spin that was serious enough to ensure that its solar panels were nearly edge-on toward the Sun, and this meant that no power was being generated. Because the spin axis is fixed in space, as the craft progressed in its orbit the orientation of the panels with respect to the Sun gradually changed, resulting in increased illumination. By August contact was re-established and, after a lengthy recovery period, the craft was again locked on to the Sun. By November, all instruments were back on target.

Bake outs

In order to keep down "noise" or "snow" interference on the EIT CCD, and to prevent cosmic ray hits from permanently raising the noise level by damaging the detector, the CCD is usually operated at a temperature of −67° C.

To achieve this passive cooling, the CCD chip is thermally connected to a titanium "cold finger" that is attached to a radiator plate pointed at a piece of sky. Unfortunately a small amount of "slush"—a mixture of water vapor and hydrocarbons—condenses on the CCD and cold finger, and this affects the performance of the instruments. To evaporate the slush, every ten weeks the detector must be "warmed up", a process known as a "bake out". This is achieved by small electric heaters on the CCD camera, which, once turned on, raise the temperature to +16° C.

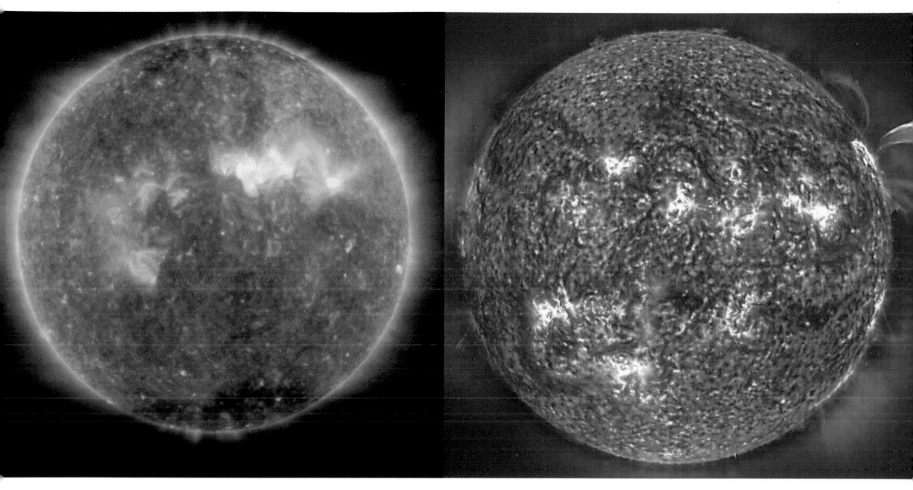

Benefits

One of the main benefits to emerge from a close study of the Sun is a greater understanding of the phenomenon known as "space weather". As electrical power grids now span entire continents, and communication lines reach across hemispheres, linked by satellites, finding out more about the effects on these extended systems caused by the vast clouds of atomic particles and magnetic fields thrown out by the Sun, is becoming increasingly important, as is the early warning of potential communications interruptions and breakdowns.

↑ **Above left and facing opposite:**
With the EIT instrument, pictures of the Sun are taken in four different colors, and each color table was constructed to bring out features of its typical wavelength. Red is the longest wavelength and blue is the shortest, with yellow and green in between. (Picture: Science Picture Library/NASA)

↑ **Above right:**
Solar prominences
This image, taken by the EIT on the SOHO spacecraft, shows dense clouds of plasma in the Sun's corona. The image was taken in the light of ionized helium, at a wavelength of 30.4 nanometeres, which corresponds to a temperature of around 60,000 K. Large prominences can cause electrical blackouts and auroral storms if directed towards Earth (Picture: Science Picture Library/NASA)

Taking the eclipse

During a total solar eclipse the Sun shrinks to a crescent, twilight descends, and the Earth darkens as the Moon starts to obscure the Sun, creating the surreal effect of night time. Capturing this event is a marvel in itself.

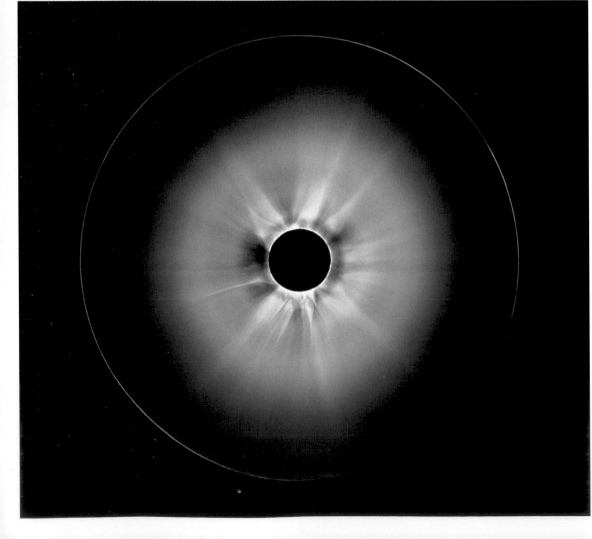

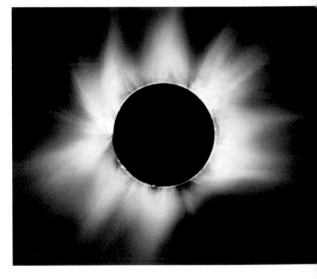

↑ **Above:**
Total solar eclipse
Solar eclipses occur when the Moon passes between the Earth and the Sun, and the shadow of the Moon crosses the Earth. At totality the Sun is completely obscured. (Picture: Professor Jay Pasachoff/Science Photo Library)

← **Left:**
Sun's coronal streamers
Optical photograph of the corona around the Sun during a total solar eclipse. The corona is the Sun's outer atmosphere of hot gases, normally invisible due to the brightness of the Sun. The black circle is the Moon. (Picture: Dr. J Durst/Science Photo Library)

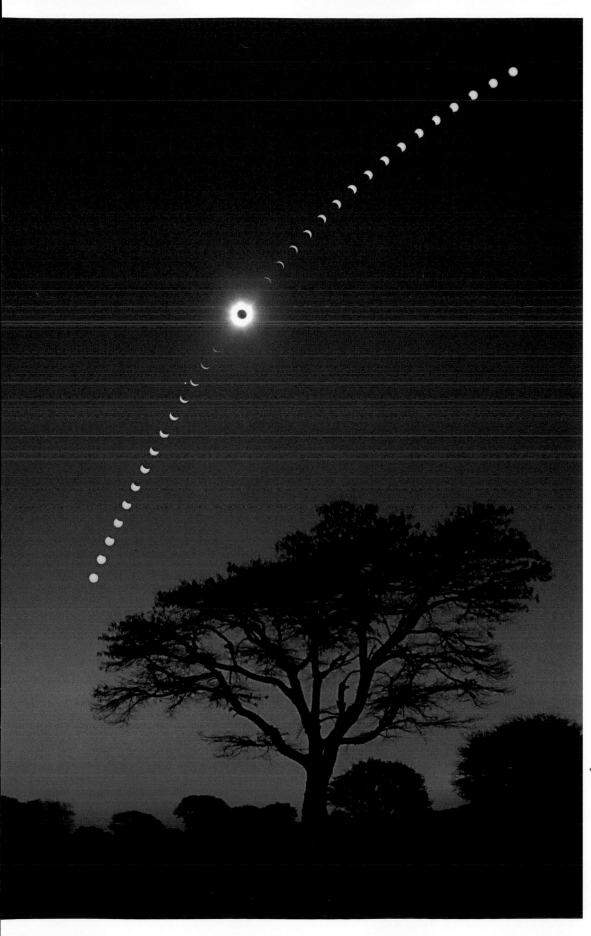

Fred Espenak

NASA astronomer Fred Espenak has been obsessed with solar eclipses for many years and he's refined his approach so that, today, he captures near-perfect representations of a solar eclipse.

For his first pictures, Espenak used neutral density filters held in front of a combined telescope/camera, which afforded protection from the intensity of the Sun. Time signals on short-wave radio allowed him to count down to totality ten to twenty seconds before he was able to remove the filters and to shoot the Sun directly. Having already framed the Sun, he was able to fire the shutter to get a full set of exposures, without having to look through the telescope, which would have endangered his eyes.

Espenak now uses several cameras, set up within a 15-foot (4.5m) radius of his position and programmed to fire automatically at 5- and 10-second intervals one minute before totality begins. The first affords a general view. Two further combined camera/telescopes, each with a fixed lens, obtain a tight and wide view of the subject,and both are fitted to an Equatorial tripod, set to keep pace with the Sun's motion. His telescopes offer the magnification of a 600–1000mm telephoto lens. Commercial solar filters are fitted over the front of these to make the camera safe for viewing.

Espenak normally shoots 15 to 25 exposures, changing the settings rapidly, and sometimes varying the shutter speed between 1/250th of a second to four or even eight seconds, to capture every aspect of the total eclipse.

Espenak scans his best images and uses Photoshop to combine them into a composite. "Finally, I was able to produce an image that looked very close to what I had seen with my own eyes," he says.

← **Left:**
Eclipse photographed from Chisamba, Zambia
Two cameras were used for this view of the eclipse above Chisamba in Zambia. One camera captured totality, while the second recorded the partial phases at five-minute intervals through a solar filter. Exposure details: Nikon 8008, Sigma 28mm at f/5.6). (Picture: Fred Espenak)

the darkest

→In a flash →Night vision →Going underground

In photography's infancy, there was no prospect of taking pictures after dark. Pioneers, such as Fox Talbot, developed the first flash photography to address this. Since those times, photography has evolved. Night vision, for example, has opened up new possibilities, even in the consumer marketplace, and will no doubt inspire future photographers.

In a flash

The origins of flash photography are surprisingly murky, but its legacy is impressive. Today, flash is essential for all kinds of photography, from capturing subjects in low light to freezing high-speed action shots.

↑ **Above:**
Engraving of early use of flash
The possibility of using magnesium for illumination in photography was known in 1859 but it wasn't until 1864 that the first portrait using magnesium light was made. The camera being used is a pistolgraph. (Picture: Science Photo Library)

Fox Talbot and the origins of flash photography
Fox Talbot is one of the best-known pioneers of photography. He used a camera obscura—an age-old device that employs a lens to project an image on to a surface—to help him tackle perspective. In the 1830s he experimented with "fixing" the image produced by the camera, and he announced his Talbotype process in 1839—the same year that, in France, Daguerre unveiled the Daguerreotype.

Independently, other nineteenth-century scientists had discovered that a brief flash of light could appear to freeze the motion of a moving object. In England, in 1833, Sir Charles Wheatstone published the results of his experiments using an electric spark to make a visual examination of fast-moving objects: "The instantaneousness of the light of electricity of high tension affords the means of observing rapidly changing phenomena during a single instant of their continued action," he reported, "and of making a variety of experiments relating to the motions of bodies when their successive positions follow each other too quickly to be seen."

It is likely that Fox Talbot was aware of Wheatstone's work, but he had made his own observations while watching raindrops, frozen outside his study window, during a lightning flash. By 1851 he was able to demonstrate to the Royal Institute in London an electrical flash that could potentially provide enough illumination for a photograph to be taken.

His audience witnessed him attaching a copy of the front page of *The Times* to a disk which he rotated as fast as possible in a darkened room. A camera was focused on the newspaper, and a series of charged Leyden jars, primitive electrical capacitors, were discharged to produce a brilliant, bright spark.

This produced not only the first flash photograph but also the first high-speed photograph—although the debate about the success of this demonstration continues to rage—and there are no surviving copies of the image that was produced.

→ **Air bubbles in water**
This effect was captured by electronic flash photography with an exposure time of 1/14,000th of a second. (Picture: Alfred Pasieka/Science Photo Library)

Night vision

There are two types of technology that enable the camera to "see" in complete darkness. The first is thermal imaging, which captures the upper portion of the infrared light spectrum and makes an image from the heat generated by a subject. The second is image-enhancement, which works by collecting tiny amounts of light, including the lower portion of the infrared light spectrum, and amplifying it to the point where it is visible to the human eye.

Thermal imaging

In thermal imaging, a special lens focuses the infrared light emitted by the objects in view, and this is scanned by a phased array of infrared-detector elements, to create a very detailed temperature pattern or thermogram. The detector array takes only about 1/30th of a second to obtain the temperature that it requires to make a thermogram, and it gets this from several thousand points in the field of view of the detector array.

The thermogram is translated into electronic impulses, and these send and translate the information into data for the display, where it appears as various colors, depending on the intensity of the infrared emission. The combination of all the impulses from the elements ultimately creates the image. A scan rate of 30 times per second is average for a thermal imaging device, and they can sense temperatures ranging from -4° Fahrenheit (-20° Celsius) to 3,600° F (2000° C), and detect changes in temperature of about 0.4° F (0.2° C).

The two main types of thermal imaging devices are uncooled and cryogenically cooled. The former is the more common, and the latter are more complicated, high-spec units, with their elements sealed inside a container that cools them to below 32 F° (0° C). Devices of this type offer the advantage of improved sensitivity and resolution, and has the capability to "see" a difference as small as 0.2° F (0.1° C) from more than 1,000 feet (over 300m) away.

Image enhancement

While thermal imaging works well in terms of detecting people or operating in near-absolute darkness, the majority of night-vision equipment utilizes image-enhancement technology. Often called night-vision devices (NVDs), these rely on what is termed an image-intensifier tube to collect and amplify infrared and visible light.

Ambient light and some near-infrared light is collected by a conventional lens, and the data is sent to the image-intensifier tube, which outputs about 5,000 volts to the image-tube components. A photocathode inside the tube converts the photons of light energy into electrons and, as they pass through the tube, similar electrons are released from atoms, multiplying the numbers by a factor of thousands using a microchannel plate (MCP).

→ **Right:**
False–color infrared image of Mount Etna
Made by a Thermal Infrared Multispectral Scanner (TIMS). The summit craters of the volcano are seen just below and to the right of center. The colors represent the thermal emissivity of the surface materials. The light blue areas show volcanic ash, the bright orange areas are recent lava flows. Older lava flows are seen as violet and pink. The yellow and green areas are regions of increasing vegetation. (Picture: Anne Kahle/JPL-Caltech/ Science Photo Library)

→ **Right**
False–color infrared image of Mount Vesuvius
Taken by a TIMS. The crater of Vesuvius is just left of center. Purple areas show deposits of volcanic ash, while older lava flows show as pink and light blue. Green areas denote vegetation. The brown region at the top is nearby Naples, and the pinkish dots south of the crater show Pompeii. (Picture: Anne Kahle/JPL-Caltech/ Science Photo Library)

← Left:
Crater of Mount St. Helens, USA
False-color perspective view of the crater of
Mount St. Helens, USA. This image was made
by combining thermal infrared data gathered
by an airborne Thermal Infrared Multispectral
Scanner (TIMS) with a digital elevation model.
The dark blue on the crater side comes from
an image of a cloud that was not removed
before the image combination was performed.
(Picture: Vincent Realmuto/JPL-Caltech/
Science Photo Library)

← Facing opposite:
Smoke plumes over Baghdad, Iraq
This visible and infrared satellite image shows
smoke plumes from the burning of pools of
oil, set alight to provide a smokescreen against
aerial attacks. This area suffered a severe
bombardment when it was invaded by
USA/UK-led forces in spring 2003. Image
obtained by the Advanced Spaceborne
Thermal Emission and Reflection Radiometer
(ASTER) sensor, carried on board NASA's Terra
satellite (Picture: NASA/Science Photo Library)

An MCP uses fiber-optic technology, and is a tiny
glass disk containing between two and six million
microscopic holes (microchannels). It has metal
electrodes either side and is contained in a vacuum.
The unit works as an electron "multiplier".

These electrons hit a screen coated with phosphorus
at the end of the image-intensifier tube, and their
energy causes the phosphorus to release photons.
The result is the characteristic green night vision
image that is viewed through a device known as an
ocular lens, which magnifies and focuses the image.
The NVD may also be connected to a monitor to
allow the image to be viewed in isolation.

The technology for NVDs has been around since
the Second World War, and the original systems
used active infrared. It was discovered that enemy
troops could use their NVD devices to pick out the
projected infrared beams.

The next generation of NVDs made use of passive
infrared, and the ambient light provided by the Moon
and stars was used to augment the normal amounts
of reflected infrared in the environment. This allowed
the units to operate without having to project a
beam. However, it also meant that they didn't
work well on cloudy or moonless nights.

With the development of the microchannel plate, the
NVD can provide images even in extremely low light
conditions. Since the MCP increases the number of
electrons, rather than simply accelerating the original
ones, the resulting images are significantly less
distorted and brighter than earlier-generation
NVDs. Today, with increased development, the
latest devices offer excellent quality.

Uses

· Riot control, suspect pursuit, and capture and
 perimeter control
· Night navigation
· Victim location
· Search and rescue
· Poaching control
· Hunting
· Weapon sights

Going underground

One of the darkest places in the world is the interior of a cave, yet there are many photographers who produce wonderful underground images.

Peter Gedei, who lives and works in Ljubljana, Slovenia, joined a caving club in 1987. He began to take pictures of this environment, and underground photography soon became a passion.

Regular caving photographers quickly realize that this is not an environment for delicate electronic gear, but for hardwearing manual cameras. Gedei uses elderly Olympus OM-2sp and OM-4T 35mm SLR cameras, and a selection of wide angle lenses, including a Zuiko 21mm, 28mm, 50mm, and 85mm. His lighting gear consists of Vivitar 283, Metz 45CT4, and Quantum T2 electronic flashguns, and Osram Vacublitz M3 flashbulbs, through to hand-held carbide, halogen, and LED lamps.

He finds that every light source has its advantages and shortcomings. Flash produces the least powerful, but also the most balanced light, so that results on daylight-balanced color film will look natural. Acetylene lights are the most powerful but they create a color temperature that records too orange on daylight-balanced film. The bulb flash offers the best compromise. It has a long lighting time, is much more powerful than electronic flash, and, crucially, it can send out light over 180°, and up to 360° if the folding fan on the bulb holder is left down. Being slower than the electronic flash, it gives the photo a softer appearance. The disadvantage, however, is that each bulb can be used only once, making it difficult to take very many pictures in one location.

Caving photographers use a limited range of shutter speeds for their work: 1/125sec, 1/30sec, and the "B" setting. The first two are the usual flash sync speeds, while the "B" setting holds open the camera's shutter, enabling the photographer to build up the image in stages via a sequence of hand-held lights and flash to effectively paint the darkness with light.

The key is to use the flash off-camera to create better modeling and to place the light exactly where it needs to be. Gedei uses assistants for this. Fitting slave units to a number of flashguns and firing them automatically via the main on-camera flash, is an option which is more complicated to set up, and the results are less precise.

Visualizing a pitch black scene when fully illuminated is a challenge, and with film cameras experience is the only way to achieve success. Gedei knows his way around cave halls very well. He is able to make quick judgments about what features should be important in the picture, and what he should be trying to accentuate, so that usually he spends only about 10 to 15 minutes on a single picture.

Facing opposite:
Jezerina, Slovenia
A couple of well-positioned, shielded lights
have enabled Peter Gedei to bring the
darkness to life. (Picture: Peter Gedei)

← **Left:**
Ledena Jama Na Stojna system, Slovenia
Even a single light can be highly effective in a
spectacular cave. (Picture: Peter Gedei)

Shots can be bracketed to provide alternative versions, and the key is to try to balance a scene so that there are no "black holes" of shadow that spoil the overall effect. Shooting near to cave openings to show the subdued, subtle lighting of these areas is another lighting challenge. The natural lighting makes it difficult to calculate an accurate overall exposure, which means that Gedei must try a number of different exposure settings to increase his success rate.

Because it can be so difficult to predict results underground, some photographers are looking at digital cameras for ways to improve their photography. They offer a means for photographers to preview their images before they shoot. Many models can be protected with purpose-made waterproof casings. Technology is driving the specialism forward, and is likely to help caving photographers plumb new depths in the future.

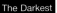

← Far left:
Musja, Slovenia
Shafts of daylight can be combined with
artificial sources to present a breathtaking
view of the caves. (Picture: Peter Gedei)

Left:
Planiska, Slovenia
The lights used by Peter Gedei vary from
← electronic flashguns and bulbs through to
handheld carbide, halogen, and LED lamps.
(Picture: Peter Gedei)

the largest

→The Mammoth →A big impression →Instant success

Sometimes, for very specific reasons, cameras can be enormous, and the quality that can be obtained from some of the very largest models is quite phenomenal. While several large-scale cameras were produced in photography's infancy, size is not restricted to antique models. Today's big cameras are used by photographers working in fine art, as well as in other, very specialized areas.

The Mammoth

The largest camera in the world was created to produce a photograph of one of the world's most luxurious trains.

Mr. Charlton, director of Chicago and Alton Railway, was determined to have a high-quality, large-format photograph taken of his favorite train, the "Alton Limited", built in 1899. When he approached commercial photographer, George R. Lawrence, it was explained that no camera could complete the task, however the railway company insisted on obtaining a perfect image, whatever the cost.

Lawrence's studio's slogan was "The Hitherto Impossible in Photography is Our Speciality," which forced him to come up with a solution. He reached the conclusion that the only way to produce a single eight-foot (2.4m) wide photograph was to make a photographic plate the same size. No camera of this size existed, so Lawrence decided to have one made, and ten weeks and $5,000 later he unveiled "The Mammoth", a camera that could take a photographic plate 56x96in (142x244cm) in size.

The contraption resembled a conventional plate camera, and it came complete with all the movements, such as the double-swing back and rising and swinging back motions, that were required to control perspective and depth of field in a picture, although a number of modifications were required to take account of its size, most particularly to the four bellows.

Some compromises to the giant camera had to be made, too. The conventional ground-glass screen was replaced by a celluloid one, saving on weight and fragility. To focus the camera so that the image was sharp in the viewfinder, it had to be slid on a track and gauged in proportion to the camera. If the viewfinder was in focus at 10in (25cm), the camera bellows would need to be extended to 10ft (3m), and so on. This was a difficult feat, requiring the assistance of two or three strong men to move the bellows into position for the shot.

Mammoth lenses and giant plates

Producing a lens presented the biggest challenge. Eventually, two Zeiss-patent lenses were specially made. One was a wide angle lens with a focus equivalent to 5½ft (1.7m), while the other was a rectilinear lens with a focus equivalent to 10ft (3m). Meanwhile, the specially commissioned glass plates used in the camera were a staggering 8x4ft (2.4x1.2m) in size, and hand-coated with an isochromatic emulsion to maintain the correct color value; each of them weighed over 100lb (45.3kg).

A special darkroom was constructed just to handle the processing of the plates. Eight men were needed to manipulate them, and 5gal (23l) of developer to process each one.

By 1900, the camera was ready. It weighed a colossal 900lb (408kg), and, when loaded, the plate holder was another 500lb (227kg). A team of 15 men was used to lift the camera on to a horse-drawn wagon, which transported it to a special train to be taken to the "Alton Limited" to be photographed.

Successful outcome

On a bright, spring morning with few clouds in the sky an exposure was made, taking approximately two and a half minutes. The lens cap was replaced and the roller curtain of the plate holder was rolled back over the plate. The result was perfect, and three contact prints were eventually made and sent to the Paris Exposition of 1900, where they were displayed in the US Government Building, in both the railway exhibit and the photography section.

So skeptical were the exhibition judges that the pictures had been taken as described, that the French Consul in New York was sent to Chicago to verify that the camera did indeed exist. He must have been satisfied, because the giant images subsequently won Lawrence the impressive World Grand Prix for Photographic Excellence.

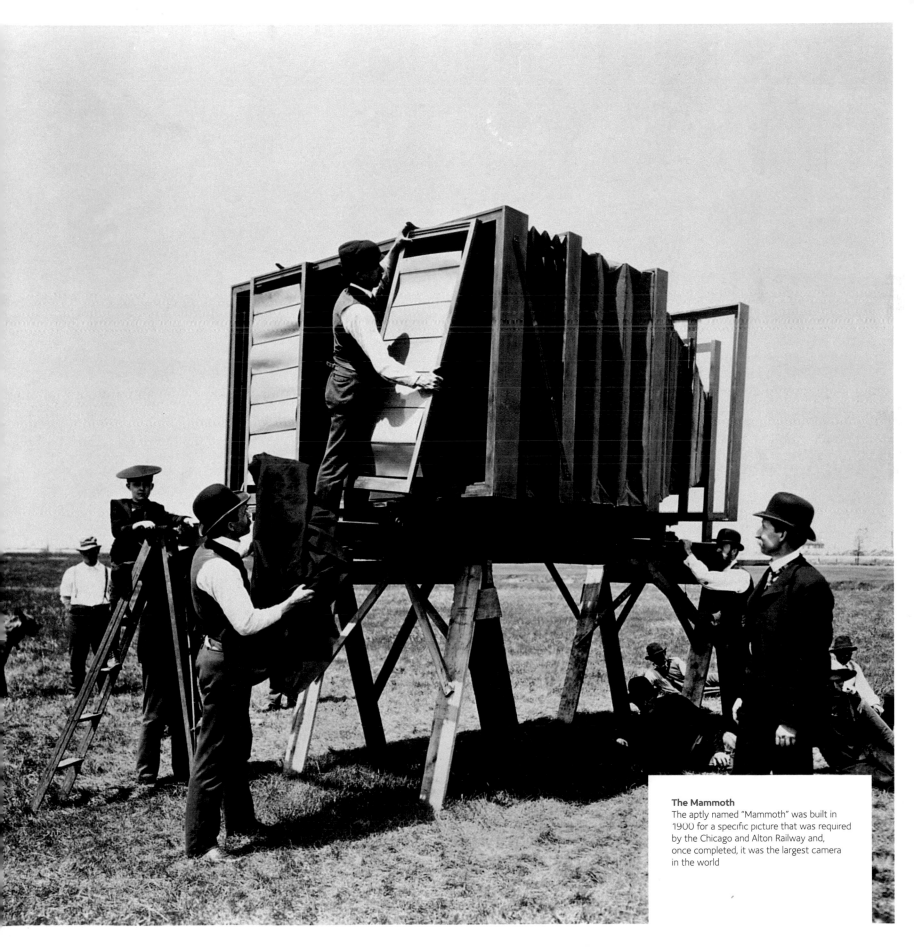

The Mammoth
The aptly named "Mammoth" was built in 1900 for a specific picture that was required by the Chicago and Alton Railway and, once completed, it was the largest camera in the world

A big impression

Fine-art photographer Allan Jenkins uses early printing processes such as salt prints and cyanotypes as the medium for his pictures, and likes nothing better than photographing his original images on a giant Lotus Rapid Field camera to create a big impression.

↑ **Above:**
The Lotus
Allan Jenkins stands next to the 20x24in Lotus camera, holding one of the giant dark slides that fit this camera. (Picture: Terry Hope)

The nature of Allan Jenkins' work is a direct result of his chosen methods. A conventional enlarger doesn't provide the necessary UV light to make the exposure when working with early printing processes, thus he is restricted to producing contact prints. As a result, he has developed an interest in large-format cameras, and as his career has grown, so has his equipment.

Starting out with a 6x6cm camera, he graduated first to 5x4in, and then to a 10x8in studio camera. He came to recognizewhat the camera could do and how best to utilize its movements. Despite the size of the negatives, his London gallery was receiving demands for even bigger images, so Jenkins researched some of the biggest cameras ever made. His pursuit led him to the mighty 20x24in Lotus Rapid Field camera.

The camera was launched amid enormous interest in 1998. Standing at human height, and weighing in at over 68lb (31 kg), it has a specially designed trolley that, at 31x25in (80x65cm), is sturdy enough to keep the camera perfectly still. Movements such as focus, front rise and fall, and front shift, are controlled by small motors, allowing the photographer to make adjustments to the viewpoint without having to venture out from beneath the dark cloth. The film for the camera is made by Bergger, and is rated at ISO 200. There are three lenses: a 750mm, a 600mm—the standard lens—and a 240mm macro lens, which can magnify the subject up to four times.

The camera in operation
Jenkins at first found the 20x24in Lotus difficult to handle. It was cumbersome to operate, slow to set up, and difficult to focus. The depth of field was extremely small and this made focusing critical. Jenkins had to set the lens to maximum aperture and bring in extra lights, stopping down two to three stops once he was sure that the focus was as close as he could get it. He also needed help from extra lights for shooting.

His still-life, studies were set up with a softbox above and to the left, with some natural overhead light. With movement less of a consideration, exposures were in the region of 10 to 15 seconds, once again with multiple flashes being used.

Cyanotypes
Jenkins has also produced what are probably the largest cyanotype prints ever made, working with a company that uses a computer process to create giant negatives. Their largest size was a massive 40x30in (100x76cm), and it necessitated a new way of working, in which Jenkins had to coat a vast sheet of art paper with his cyanotype emulsion. The result is hung up to dry, then placed on a piece of wood 8ft (2.4m) across and two people maneuver a piece of glass the same size to cover it. A huge ultraviolet light box is used to make the exposure, which takes from 12 to 25 minutes.

At the appropriate moment, the print is removed and washed with constantly flowing water until the yellow background has disappeared and the image is bright blue. As it exposes to oxygen, it turns a deeper shade of blue. Jenkins then tones it down with tannic acid, which turns it a pleasing shade of muted brown.

The considerable effort behind each print seems to be worthwhile. "Size really does seem to matter," says Jenkins. "I sold three of the giant prints through the gallery in one week and it seems that this is what the collector is looking for."

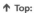 **Top:**
Master and creation
This image, taken by Eddie Ephraums, shows Allan Jenkins holding one of his giant images, giving a true sense of scale.

→ **Right:**
A large cyanotype by Allan Jenkins
The large-format still studies that Allan Jenkins produces have proved to be extremely popular with collectors of fine art prints.

Instant success

Polaroid's five massive 20x24in "instant" cameras have achieved celebrity status since they were created in the early 1970s. Offering a format that is about as large as most photographers choose to go, they appeal to those who like to go back to basics and to work with a camera that has clear links to photography's origins.

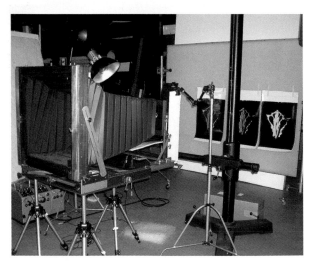

↑ **Above:**
The giant Polaroid camera
The Polaroid 20x24in format has become a favorite of fine-art photographers, who like the unique images it creates, and its links to photography's past. (Picture: Terry Hope)

These enormous cameras, which weigh 235lbs (106kg) and stand 5ft (1.5m) tall and the same in length, are essentially no more than a box with a lens on one end and a film plate at the back. In between is a set of bellows that alters the distance between the two to allow for focusing. Everything is operated manually.

The story of Polaroid's involvement with the 20x24in format is said to have its origins in an anniversary present for one of the company's pioneers. The idea was to present Howie Rogers, Polaroid's Director of Research and the inventor of Polacolor film with a portrait, and the camera chosen to perform the task was a Robertson Loge process camera with a Polaroid back. The largest image size that this camera offered was 20x24in, which is rare for conventional cameras. The picture was a big success. Dr. Edwin Land, founder of the company and the inventor of the Polaroid instant process, became very enthusiastic about it. Dr. Land was about to introduce Polacolor film in 8x10in format, and he thought it would be dramatic to introduce the film by showing off its capabilities in the 20x24in format. The plan was to photograph a subject at the shareholders' meeting.

Given the tight time scale, the first camera was somewhat crude, weighing 600lb (272kg), and employing a barber's chair support in lieu of a tripod, but nonetheless it made spectacular images.

Following this debut, five cameras were designed and constructed by Polaroid. The cameras have travelled the world, and have been used by a number of high-profile photographers. The early sessions yielded images by Andy Warhol, Arnold Newman, and William Wegman. Joyce Tenneson shot the entire 1989 Pirelli Calendar with the camera, using a dedicated studio in New York.

Working the camera, and making sure that the giant rolls of Polaroid material it requires are loaded and processed correctly, means that the camera is hired with the services of a full-time operator. Each picture takes 90 seconds to process. The big attraction for the fine art market is that every image produced is unique. There is no negative, and although a duplicate can be taken at the time of shooting, it will never be exactly the same as its predecessor.

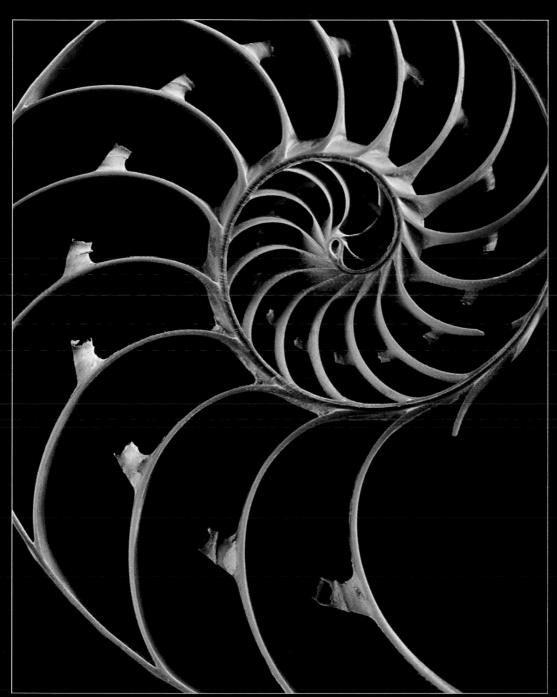

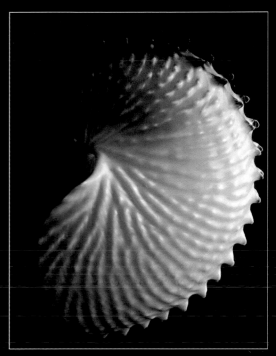

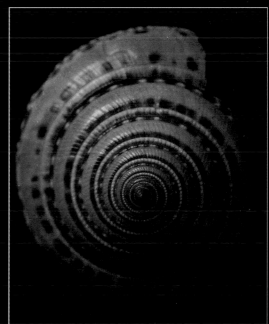

↑ **Above:**
Giant polaroids by Seamus A. Ryan
These delicate 20x24in Polaroid prints were
created by artist Seamus A. Ryan, who is a
regular user of the format. Each picture is
unique, and carries a heavy price premium
as a result.

Largest instant camera

Astonishingly, the biggest Polaroid model ever to have been made is a single 40x80in model, the world's largest instant camera, which was built in 1976 and now resides in New York's Manhattan at Moby C, a studio in the East Village. It costs upward of $2,000 a day to hire, plus a further $500 for every shot. The camera is so huge that it requires a front and a rear camera operator, and it can capture a life-size portrait of a person.

"The camera is 12ft (3.6m)tall, 16ft (4.8m) deep, and 12ft (3.6m) wide," says Mark Sobczak, who has been operating it since 1994. "Its lens is 7ft (2.1m) off the floor, and to take full-length portraits the subject has to stand on a platform that brings them up to the level of the lens. The camera also has about 5—6ft (1.5–1.8m) of bellows extension, although this is mainly for magnification, and everything from a one-to-one result to a 12x magnification is possible.

"Focusing is usually carried out by the subject moving slightly backward or forward until they are where they need to be to be sharp, and it's critical to get this exactly right because even stopping down to f/64 won't add much to the depth of field. Normally we keep it between f/32—45, and work around that."

Sobczak initially works inside the camera, observing the vertical inverse image that is being projected into the focusing plane and directing until the subject appears sharp, while the photographer stands alongside organizing the picture. With everything set up, the lights in the studio are cut, and Sobczak exits the camera and loads the film holder. The film itself is pulled down into position and held in place from the rear by vacuum suction. There is no shutter: the studio is in darkness until the intense burst of light from the flash units makes the exposure.

Documentary use

The camera came into its own following the attack on the World Trade Center. Photographer Joe McNally, who had encountered it while working on an assignment for *National Geographic*, considered it to be the most evocative format for documenting the rescue workers, New York City officials, survivors, and relatives of the victims. Many of the rescue workers were pictured in the studio direct from their duties—still covered in the dust and grime from the site. It turned into a three-and-a-half week marathon, and yielded 227 massive prints that have since made an intensely moving exhibition.

↑ **All images:**
Seamus sells seashells
By using full bellows extension on the
Polaroid 20x24in cameras, it's possible to
produce breathtaking macro images.
(Pictures: Seamus A. Ryan.

the
smallest

→Microscopic journey →Queen Mary's dolls' house cameras
→Subminiature and spy cameras

Tiny cameras and miniature prints have always been popular, not only for fashion or convenience, but sometimes for political reasons. For espionage, cameras have been disguised as buttons, pens, watches, cigarette packets and lighters, and it's anyone's guess what cutting-edge imaging and transmission devices spies of today might conceal.

Microscopic journey

Amateur photographer John Benjamin Dancer was a pioneer of early miniature photography. His techniques formed the basis of modern spy cameras, and microfilm and microdot technology.

John Benjamin Dancer manufactured Daguerre cameras in his home town of Liverpool, in the UK, in 1839. He also offered to process Daguerrean plates taken by local photographers for a fee, establishing the first commercial photofinishing business outside of France. Like many of his era, he was an avid microscopist, and he produced his first microphotograph by attaching a microscope lens with a focal length of 1½in (3.8cm) to one of his Daguerre cameras. This was not a photograph of a microscopic subject—rather it was a very small photograph of its subject, and the first photograph featured a document that was 8x20in (20x50cm) in size at a reduction ratio of 160:1, so that the actual image was ⅛in (3mm) in length and could be read easily under a magnification of 100x, the standard magnification of microscopes of that time.

Smaller and smaller

Captivated by his results, Dancer went on a quest to produce more advanced microscopic images. He became so involved in his search to produce better optics that he even experimented with Daguerreotype cameras that featured lenses extracted from the eyeballs of slaughtered animals.

Taking advantage of modern trends, Dancer was impressed by the Collodion wet-plate process, which he first used in 1852. In 1853 he succeeded in photographing the inscription on the gravestone of William Sturgeon, reducing the 680 large characters to a wet-plate frame 1/16in (1.6mm) in size.

Dancer's microscopic images were becoming highly collectible novelties of their time, and they became increasingly complex as he created intricate montages that might contain 150 tiny portraits in a single frame barely 2mm (⅛in) in diameter. These could sell for up to a shilling a time, and soon the pictures were being coveted and collected by the upper echelons of society—even Queen Victoria had a set of microportraits of the large royal family. By 1873, the choice of subjects available from his catalog had grown to 277, and the photofinishing factory turned out his images en masse.

At his death in 1887, the collection had grown to 512, but, as with all fashion trends, the vogue for miniature portraits eventually passed. The collection was sold on and last marketed in the early years of the twentieth century. The processes that Dancer had helped to pioneer, however, eventually had great value in other areas of photography, particularly in the world of espionage where they ultimately led to the development of the microfilm and the microdot.

→ **Facing opposite:**
150 Portraits of Eminent Persons
Facing: the classic "150 Portraits of Eminent Persons" by John Benjamin Dancer was so tiny that it was supplied in a frame just 2mm in diameter. (To give you an idea of just how small that is, it would fit inside this square: ☐.) (Picture: The Museum of Science and Industry in Manchester)

Queen Mary's dolls' house cameras

Queen Mary, the wife of King George V, had enormous enthusiasm for collecting miniature objects. A superbly detailed dolls' house, including a tiny camera, was created in her honor.

The dolls' house was made for the British Empire Exhibition held in London, in 1924. It was designed by the celebrated British architect Sir Edward Lutyens. Leading manufacturers were invited to contribute miniature versions of their products and, as an appointed supplier to the royal family, Kodak was approached and invited to make a tiny camera.

Technicians from the Kodak camera repair works in London took on the challenge wholeheartedly, deciding to produce a model that was fully operational and complete in every detail. The project involved four people for a total of six weeks, and the result was a 1/8 scale version of a model 2C Brownie box. Not only was the camera perfect in its exterior appearance, it was also capable of taking clear photographs, and it appeared to have met the brief in every way.

Unfortunately, however, when the company directors saw the camera they thought that it was too humble a model. They considered that a grand house would, in real life, have something more sophisticated, and they instructed the technicians to make a second, more exclusive, folding model. The technicians rose to the challenge and produced a working-scale model of a No. 3A Autographic Kodak, an achievement that was reported by *Amateur Photographer* magazine in July, 1924.

"Every part had to be made separately by hand, with the aid of jewelers' tools and a microscope. The lens is formed from a crystal, the shutter actually works, and there is the usual reversible finder, and even the pencil for the autographic record. The camera is made to the linear scale of one inch to a foot, so that it is only 3⁄4in (2.5cm) high, and its volume 1:1728 of the original. The bellows offered the most tiresome problem and, after many unsuccessful experiments, it was found that paper was the only satisfactory material for this delicate job."

The dolls' house became a major attraction at the Exhibition, where it was seen by over 1,500,000 people, and at the Ideal Home Exhibition in 1925. Since that time it has been on public display in Windsor Castle. The first, unsuccessful camera is housed in the Kodak Museum, Bradford, England.

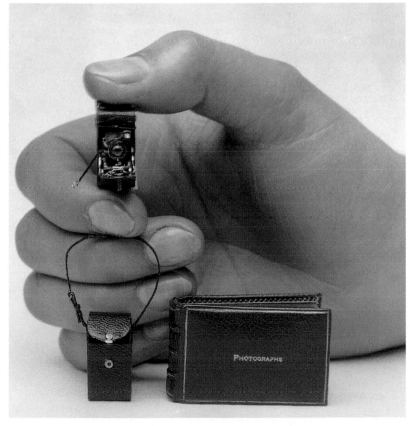

↑ **Top and left:**
Folding cameras
This tiny folding camera was created by Kodak engineers for the dolls' house that was shown at the British Empire Exhibition in London in 1924. Although completely miniaturized, it is still capable of producing genuine photographic images. (Pictures courtesy of the National Museum of Photography)

Subminiature and spy cameras

Even in the early years of photography, there was a strong demand for tiny cameras that would take reasonable pictures while doubling as novelty items. There were far too many to give more than a few examples of the range.

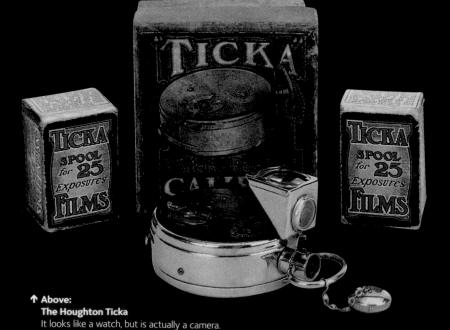

↑ **Above:**
The Houghton Ticka
It looks like a watch, but is actually a camera.
(Picture: Christie's Images, London)

The Houghton Ticka

The Houghton Ticka, patented in 1904, contained an innovative film cartridge that could be dropped into the camera body, where it meshed with the film-winding key. A counter kept a log of the exposures made. The British Journal *Photographic Almanac* gave this camera an enthusiastic mention in 1907: "Messrs. Houghton have introduced a watch-form camera, taking roll film, sufficient for 25 exposures, and giving negatives which, when enlarged to about 3x 2in (7.5x5cm), yield quite excellent little prints. The apparatus, though so compact, is nevertheless better than a toy, for the depth of focus given by a lens of such short focal length is very great, and the negatives will stand enlargement well."

Two more models followed in 1908, the latter of which was soon discontinued, going on to become the rarest production Ticka of all. Another valuable model is the Silver Ticka. It seems likely that Queen Alexandra, who was an accomplished photographer, was presented with a special Silver Ticka that was engraved with the royal monogram.

The Ticka enjoyed its greatest longevity in the US, where a set of colored cameras were manufactured in 1935. Japan produced an identical copy from 1910 onward, called "the Moment", styled in exactly the same way as the Ticka.

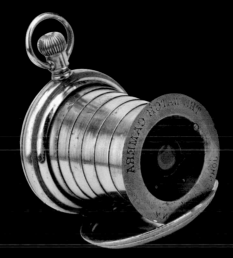

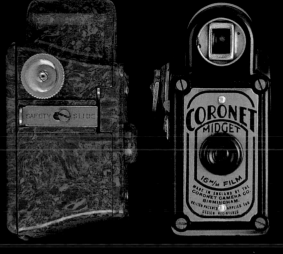

Watch cameras

The vogue for gentlemen's pocket watches led to the manufacture of novelty cameras that were like fob watches. The Photoret camera was based on a design by William L. Dickson, an assistant to Thomas Edison. Its novel shutter made use of a sliding sprung disk that gave an exposure time of 1/10th of a second.

In the form of a hunter watch, and nickel-plated, the camera took six hexagonal images ½in (1.3cm) across on a disk of film 1¾in (4.4cm) in diameter. Its drawback was that it had to be loaded and unloaded in a darkroom. It came with a range of accessories, including an enlarger, printing frame, and processing materials. Despite all this, the camera had disappeared from catalogs by 1900.

The Coronet Midget

The Coronet Midget was introduced in 1934 on the back of the vogue for subminiatures. It was made by the Coronet Camera Company of Birmingham, England, who specialized in the production of mass-produced cameras for the amateur. The model was described as being "in every way a real camera and not just a novelty or toy."

In reality this was a somewhat optimistic statement. The model, made from Bakelite and weighing just 2½oz (71g), featured a single meniscus f/10 lens, which focused from 5ft (1.5m) to infinity and a 1/30sec single-speed shutter, and used film 16mm in size, which was never likely to yield a high-quality result. Still, the model was tiny enough to be marketed as "the world's smallest camera," and was offered in a range of colors with different mottled finishes.

Production of the camera ceased at the outbreak of war in 1939, but the principle of tiny cameras had been well-enough established for a new model, the Coronet Cameo, in around 1948. This was 2x1x1in (5x2.5x2.5cm) in size, and made of black Bakelite with alloy fittings. It had a fixed-focus f/11 lens, a shutter speed of 1/25sec, and it produced a tiny negative. It was still available as late as 1952.

Above:
The GF-81 ring camera
A camera built into a genuine gold ring, it could
make fast shutter speeds. (Picture: Christie's
Images, London)

Ring cameras

One of the smallest cameras ever was the GF-81. It was made in the early
1980s by Italian camera designer and manufacturer Gian Paulo Ferro at his
Udine workshop. Built into a genuine ring and finished in gold, the only real sign
that this is anything out of the ordinary is provided by a tiny protruding right-
angle viewfinder and, despite its miniature size— less than ⅛in (just 25mm) in
diameter—this amazing model features shutter speeds of 1/30–1/500sec and a
focusing f/2 lens. A special film punch for stamping out the film disks necessary
for loading in the GF-81 and a minuscule development tank for daylight film
developing were also supplied as accessories.

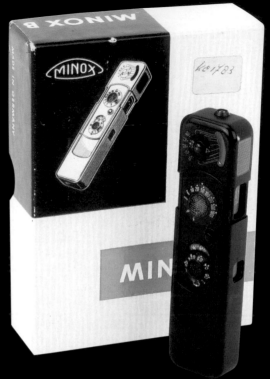

↑ **Above:**
The Minox spy cameras
Arguably the most glamorous of all miniature
cameras, the Minox range is legendary.
(Picture: Christie's Images, London)

The Minox

One of the most famous subminiature cameras of all time is the Minox, designed
by German Walter Zapp. The revolutionary technology was developed in the mid-
1930s, and today it is still the smallest series-built camera in the world.

After some patent and design problems, the camera went into full production in
1938 at the Valsts Elektrotechniska Fabrika (VEF) in Riga, the largest electrical
appliance company in Latvia. It was here that, up until 1942, a total of 17,000
cameras were manufactured and marketed around the world. While the Second
World War brought the burgeoning success of this tiny camera to a temporary
standstill, the production of the camera began again, in Germany, in 1948. Just as
sales began to soar, however, internal disagreements brought his involvement to
an end, intensified by the escalating Cold War, and which saw increased use of the
Minox camera for espionage.

In 1996, after a gap of 40 years and following a major crisis at Minox that saw
the company taken over by Leica, Zapp was rehired as a development engineer.
He died in 2003, but the camera he created lives on, with sales now approaching
the 1,000,000 mark worldwide. It made a name for itself as the ultimate
miniature camera at a time when even 35mm was considered to be too small
to be serious, and it has forged an unrivaled reputation.

↑ **Above left and right:**
Spy cameras to die for
This pack of John Player cigarettes and leather handbag are synonymous with 1970s spy movies. (Picture: Christie's Images, London)

↑ **Above:**
The Petite lighter camera
Dating from the 1960s, the Petite came in a range of styles and finishes. (Picture: Christie's Images, London)

↑ **Above:**
Minox DD1
Updating the Minox range, the DD1 combines digital and miniature technology. (Picture: Minox (Germany)

Spy cameras

The association between photography and espionage has been long and fruitful. A tiny camera could be secreted about a person's body or hidden inside an everyday item, such as a clothes brush, and smuggled into places of high security. Its other advantage was, and remains, its extreme simplicity to operate.

Tiny cameras have, over the years, become even more discreet. Cameras have been designed that will operate from the inside of a briefcase, or a coat—with the lens doubling as a button. They have also been disguised as cigarette lighters, matchboxes, or packets of cigarettes. The Kiev 16mm model, for example, is the classic spy camera model from the 1970s, disguised to look like a packet of John Player Special cigarettes. Its elongated metal body, painted black with the John Player name and logo, faithfully reproduced the originals, while the cigarettes poking from the top of the packet are actually controls for the focus, aperture, and shutter.

The Petite Lighter camera, meanwhile, is an example of a camera that has been designed to look like a benzine-fuelled lighter, although a close examination quickly reveals the lens and wind-on knob. Dating from the early 1960s, it came in several colors and styles, including blue, red, and green enamel, and brown imitation leather.

Modern miniatures

The appetite for tiny cameras know no bounds. Digital still cameras and camcorders have shrunk down to tiny sizes. Unlike their past relatives, many offer high-quality results that rival 35mm film cameras. Digital cameras can fit inside pens and mobile phones, and camcorders have switched to solid-state media, offering outstanding moving images and sound, together with 10x optical zooms—while being no bigger than the size of a credit card.

Minox is still at the forefront of miniature camera design. Its latest offerings are tiny replicas of famous cameras, such as the Leica 35mm Rangefinder and the Hasselblad medium-format camera. Another offering, the Minox DD1, is a tiny 3-megapixel digital camera with a circular button-style design, which is just under 3in (7.5cm) in diameter and weighs less than 4oz (120g).

There seems to be no practical limit to which optical products can shrink. If the technology is there, someone will most certainly produce smaller and smaller products, and the modern trend seems set to continue for the foreseeable future.

the weirdest

→Holography →The Kirlian effect →Stripping off →Pinholed

Many kinds of extreme photography defy classification. An image may be the final result, but the means by which it was contrived may well appear to have more to do with science fiction than conventional photographic methods.

Holography

Holography is hardly a new discovery, but the potential of this curious technique, an example of true three-dimensional imagery, remains to be exhausted.

All images:
Strange experience
Holograms are difficult to show in two dimensions, and really need to be seen in the flesh, when it's possible to walk around the image and view every angle, almost as though it were a solid object. (Pictures: courtesy of The Museum of Holography in Chicago)

Holography was discovered by scientist Dennis Gabor in 1948, and in the 1970s, he was awarded the Nobel Prize for his achievements. Research continues into the possibility of holographic television, and holographic images are exhibited by art galleries. In the flesh, they are inspiring, but even on paper they are astonishing.

A hologram is a lightwave interference pattern recorded on a holographic plate (or other suitable surface) that can produce a three-dimensional image when properly illuminated. The image projects outward so that it appears to be a tangible object. The viewer walking around the projection is presented with new visual information from every angle.

To create a hologram, a laser beam is split into two. The first part is spread over a lens or curved mirror and is directed at the film plate, and the other is directed to hit the object, which then reflects light on to the holographic film plate. At this point, the beams interact to form an interference pattern on the film, producing the hologram.

In addition to its novelty value, holography has medical applications, such as enabling CAT scans (see page 71) to be combined into a three-dimensional image.

Types of Hologram

- The transmission hologram is made by arranging for both split beams to hit the film from the same side, and the result has to be viewed by laser light.

- The reflection (white light) hologram is made with the split beams approaching the holographic plate from opposite sides and is viewable with white light such as a spotlight, a flashlight, or sunlight.

- A multiple channel hologram has two or more images that are viewable from different angles.

- The real image hologram is usually a reflection hologram made from a transmission original. The image is projected in front of the plate toward the viewer, and most holograms displayed in museums and galleries are of this type.

- Mass-produced holograms can be created by several different methods. They can be produced by stamping a metal master on to the back of foilbacked mylar film or they can be made on polymer, a lightsensitive plastic, and the hologram can be recorded on to a lightsensitive coating of gel that contains dichromate.

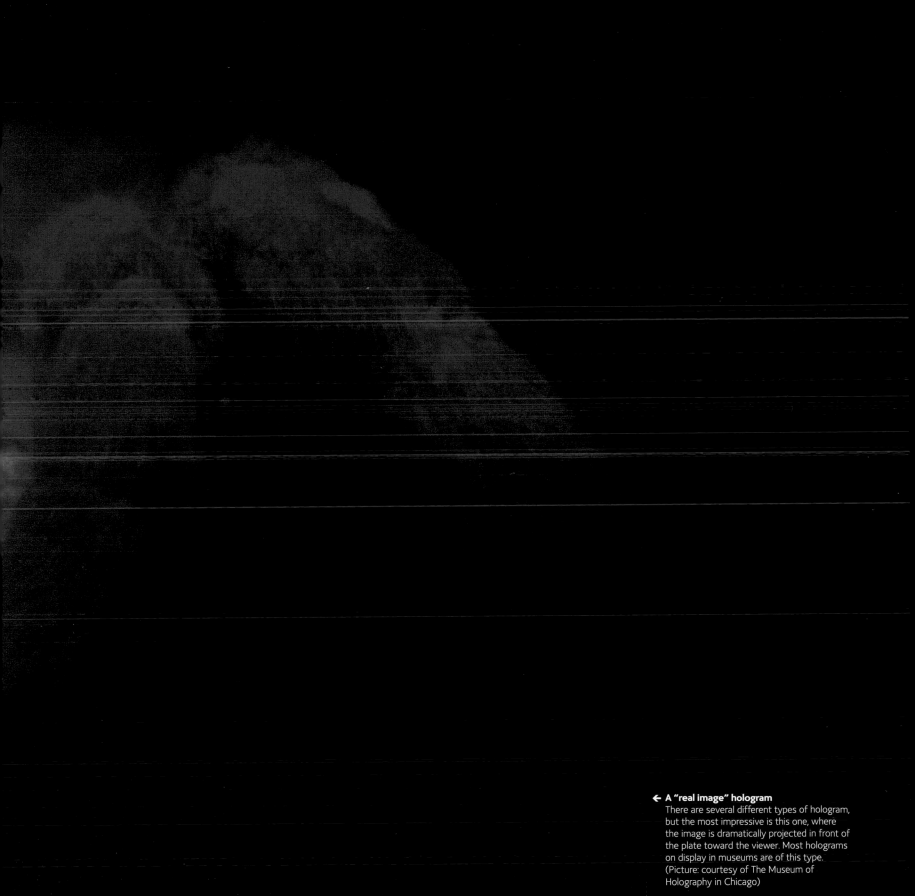

← **A "real image" hologram**
There are several different types of hologram, but the most impressive is this one, where the image is dramatically projected in front of the plate toward the viewer. Most holograms on display in museums are of this type.
(Picture: courtesy of The Museum of Holography in Chicago)

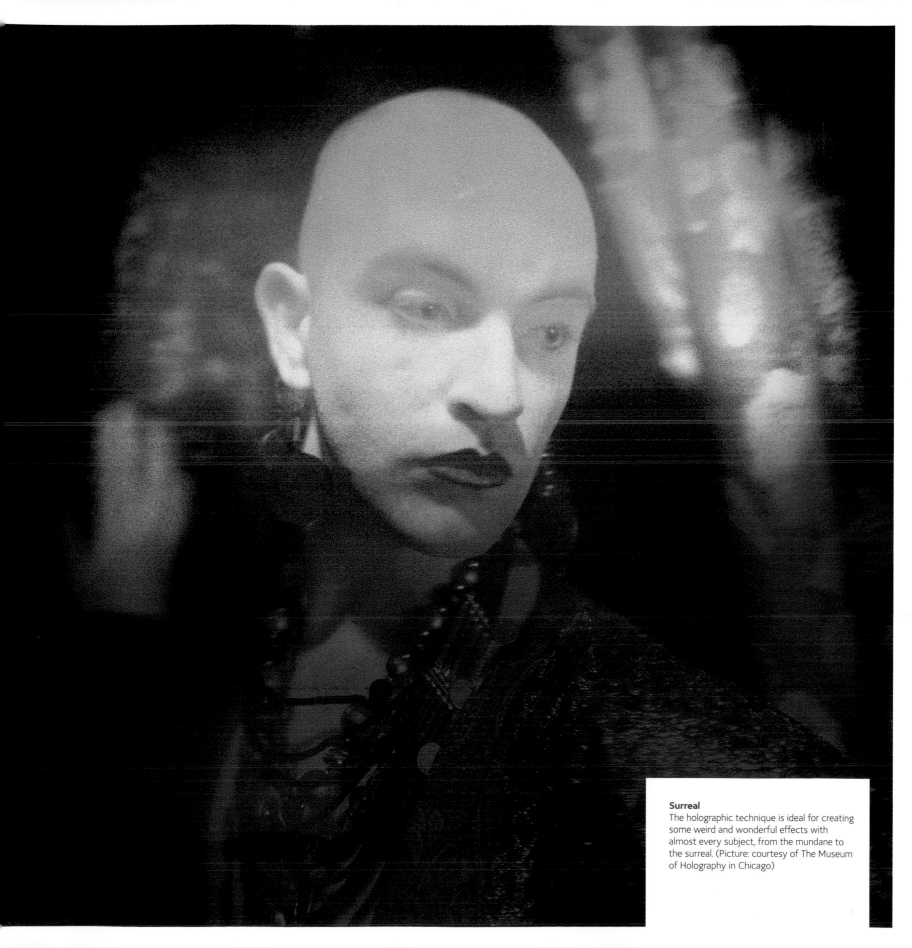

Surreal
The holographic technique is ideal for creating some weird and wonderful effects with almost every subject, from the mundane to the surreal. (Picture: courtesy of The Museum of Holography in Chicago)

The Kirlian effect

Kirlian photography records a subject's electrical aura. Some claim it has the ability to record early symptoms of disease, and potential medical benefits.

→ **Right:**
Kirlian image of human fingertips
The Kirlian technique (also known as electrophotography, high voltage photography, radiation field photography, or corona discharge), obtains a photographic image due to the high-energy interactions between the subject and an applied electric field. No external light source is used; light emitted as photons from the electrical interaction causes the image on film. (Picture: Natasha Seery)

Discovered in 1939 by Valentina Kirlian and Professor Semyon, Kirlian photography records energy fields surrounding objects and living organisms. In a darkened room, low-voltage electricity is passed through a plate with a sheet of film on it. The object is placed directly on top of that. A small object needs to be attached to an earth wire to conduct away the electricity, while a human subject can be earthed by touching the floor. The film captures the object's reaction to the current and the surface of the object makes its image directly, without a lens, like a contact print.

Negative film stock is used, and the ISO speed is important—the faster the stock, the more receptive it is to the light, and the more heightened the effects. The distinctive feature of Kirlian photography is its blue tone, but this can be varied by exposing images through colored gels or filters.

The condition of the subject is integral to the process and the subsequent results. If the subject is organic, the aura will be affected by its condition: for example, imaging a fruit or a vegetable before and after it has been microwaved, will produce radically diverse results.

Kirlian photography is used by some practitioners of alternative medicine to detect energy blocks and early signs of disease. Some claim its usefulness for assessing the effectiveness of treatments, or to monitor changes in health. The photographs are taken by contact with the fingertips or hands, where empty spaces or flares in an image can reveal blocked energy. Photographer Natasha Seery uses a specially built machine to undertake high-profile campaigns for clients researching commercial applications of Kirlian photography. Such is her belief in Kirlian, that she donates her fees to aid research into medical applications of the technique.

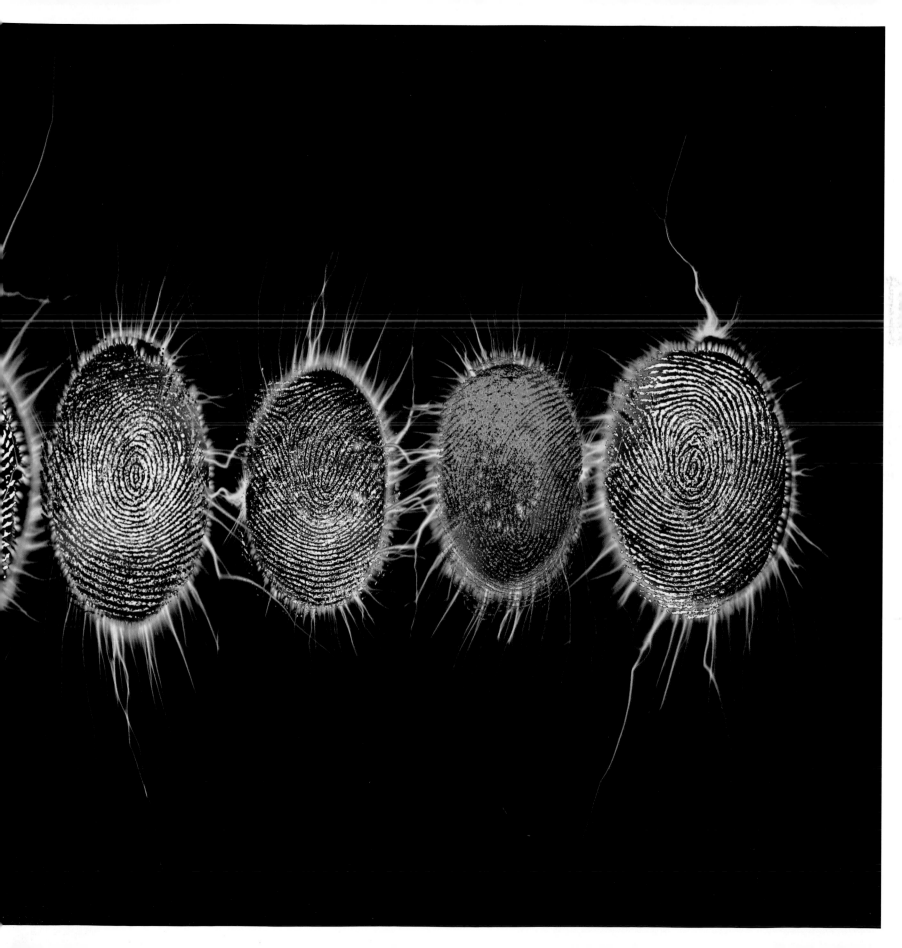

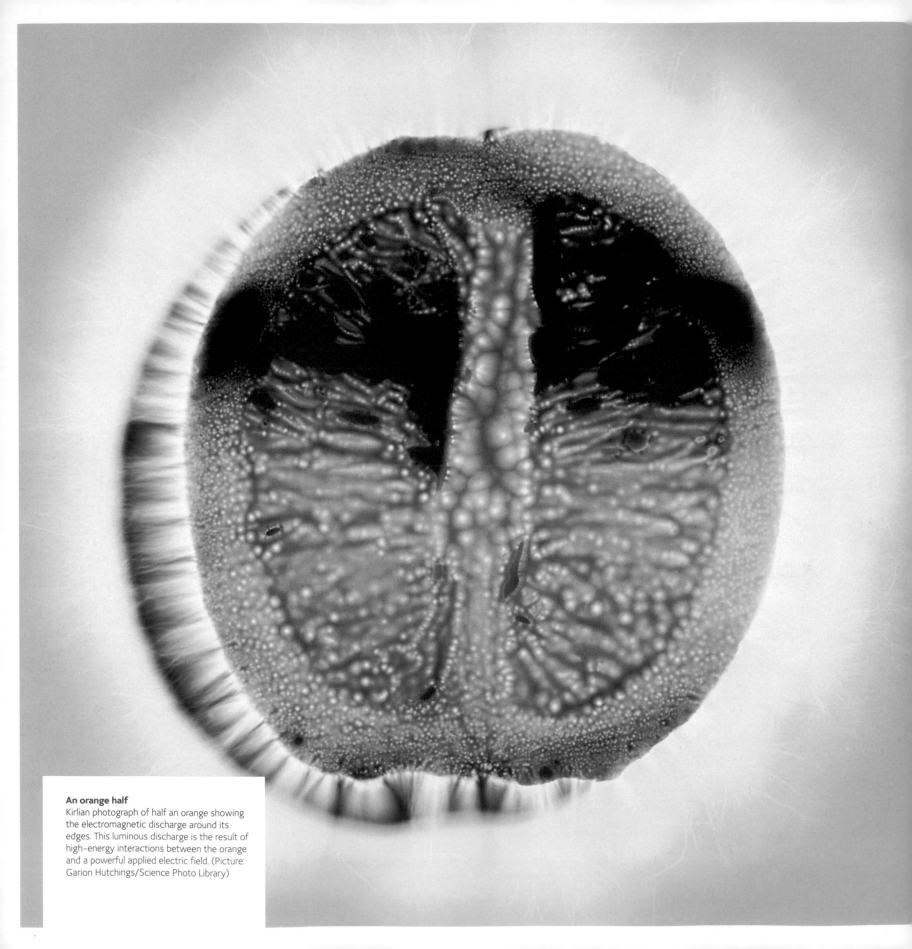

An orange half
Kirlian photograph of half an orange showing the electromagnetic discharge around its edges. This luminous discharge is the result of high-energy interactions between the orange and a powerful applied electric field. (Picture: Garion Hutchings/Science Photo Library)

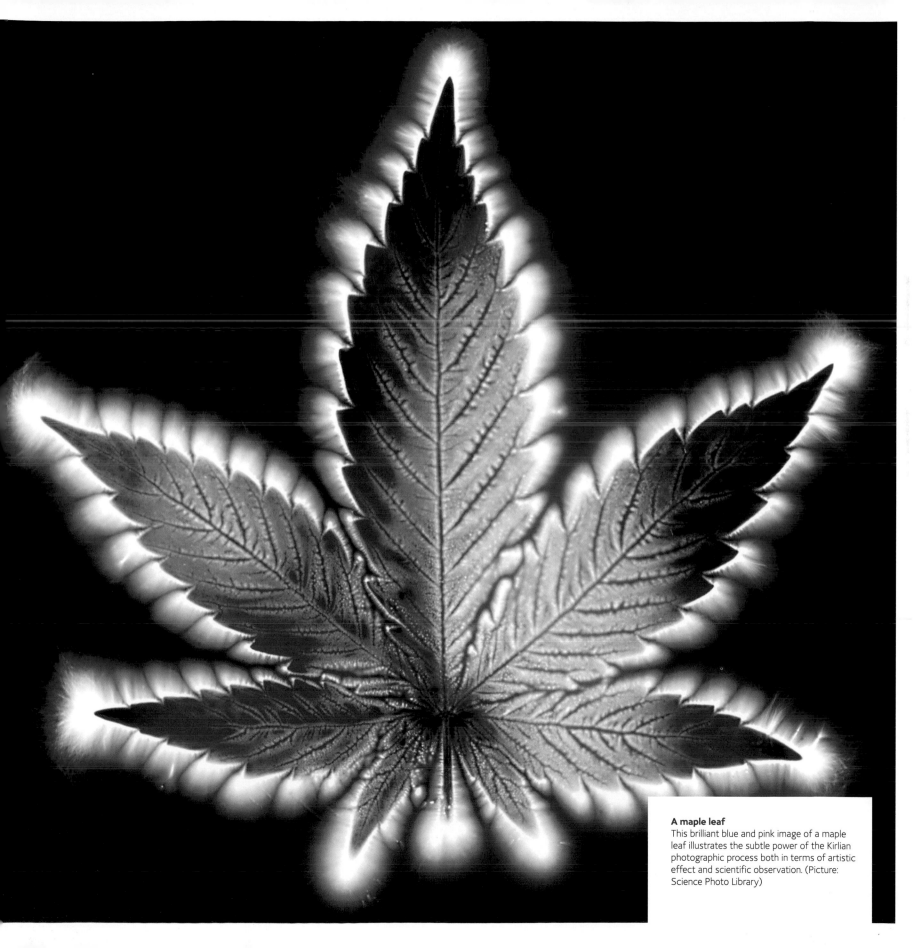

A maple leaf
This brilliant blue and pink image of a maple leaf illustrates the subtle power of the Kirlian photographic process both in terms of artistic effect and scientific observation. (Picture: Science Photo Library)

Stripping off

One of the most effective ways to depict movement in a still picture is the pan. A twist on this technique is provided by strip photography.

There are a number of ways to depict movement in a still picture. One of the most effective is the pan, in which a camera follows a moving subject during the exposure. This maintains the sharpness of the subject while the background is blurred. A twist on this technique is provided by the strip camera. Originally devised to provide photo-finish verification of athletic events, the strip camera remains still while the film inside moves during the exposure to retain sharp focus on the subject.

Several photographers have adapted this principle for creative purposes. Andrew Davidhazy produces images by making simple alterations to conventional 35mm photographic gear to change its fundamental operation. "The principal requirement for strip photography is that the camera be capable of moving the film while the exposure is being made," he says. "This can be accomplished by using the rewind mode of a 35mm camera. The film is rewound into the chamber, either without modification or by attaching an oversized lever to the knob to make it easier.

"The film is first transported into the take-up spool by firing off the available number of exposures with the lens cap on the camera lens. Then the shutter is opened on "B" and kept open through the use of a locking cable release, and once done, the rewind button is pressed. Now the film is free to be rewound into the supply cassette past an open camera gate."

With the shutter open and the film moving, one might imagine that the camera would not be able to record anything but a very blurred picture. But Davidhazy

plays with movement and speed to ensure that the moving subject in the image ultimately appears stationary, while, conversely, the static background appears blurred. A great deal of experimentation was required to refine the technique. Davidhazy reduced his exposure times and increased sharpness within his images. He also looked for subjects, and took a lot of pictures on the New York sidewalk, achieving some interesting results.

"When people walked past the camera at the right speed they left an impression on the film that was close to their true resemblance," he says. "If they moved too slowly, their images stretched; too quickly and they were compressed."

Davidhazy also set up studio portraits, where the subject was rotated on a turntable at a rate of one revolution every ten seconds while the film was in motion. These curious images show a face apparently unfolded, with both sides, as well as the front, included in the view.

The technique has been brought bang up to date by the introduction of digital technology, utilizing a conventional scanner. The rate at which the scanner acquires data determines the degree to which a subject is reproduced, and results to date have been highly encouraging. Davidhazy has created some very individual images, and he has not exhausted the boundaries of home-produced strip photography yet.

Both images:
Multifacted
The highly specialized strip camera was originally devised to provide photofinish pictures, and the camera remains still while the film inside moves during the exposure. These two images are perfect examples of this technique. (Pictures: Dr Andrew Davidhazy)

Pinholed

The pinhole camera is distinct from most others: it doesn't use a lens. Instead, the image is made via a very small hole, and the result, while lacking the level of crispness that one would expect from a dedicated resolving lens, is detailed enough to view as a conventional photograph.

Above and facing opposite:
Open-mouthed
The images shown are both taken with a 110 cartridge camera placed inside Justin Quinnell's mouth. Lighting is provided by two flash guns, located at 10in (25cm) from the main subject. The flash units are slave-synchronized and fired manually using the "open flash" technique. The exposure is f/56 on ISO color negative film. (Pictures: Justin Quinnell)

Pinhole power

The pinhole camera is fundamentally different to most others in one distinct way: it doesn't use a lens. Because of the way the picture is created, with light passing through a tiny hole in the camera, many of the conventional controls of a regular camera are redundant. A shutter is not required because the exposures take such a long time. Instead, a length of opaque material is taped over the pinhole when a picture is not being taken. There is also no regular aperture or shutter speeds: the light comes through the hole and, if it is the right dimensions, the image will resolve on the film.

The beauty of the pinhole camera is its emphasis on improvization. Virtually anything can be made into a pinhole camera: a cardboard box that has been painted matt black on the inside is one way, but a room with four walls and a partially masked window can be used, too. There is also no theoretical limit to the size that a pinhole picture can be: the bigger the space that is utilized, the larger the final image.

Open wide

Few photographers have mastered the art of introducing genuine humor into their pictures, but Justin Quinnell's strange, and marvellous pinhole images succeed.

Quinnell's cameras are extremely simple. They range in size from one that is just about small enough to fit inside the mouth to one that can fit a whole human being. Their skewed perspective of the world, offer unusual images, from the mundane to the fantastic.

Quinnell's smallest camera uses 110 cartridge film, with a miniature body made from a 28x45mm piece of thick aluminum foil from a drinks can. Before assembly, the center of the foil is carefully penetrated with a needle to make the smallest possible pinhole. The foil is then folded to make a U-shaped bridge, designed to fit between the two film chambers of the cartridge. Final construction stages involve painting the inside of the foil with matt black paint, removing part of the cartridge to allow access to the film transport cogwheel, fitting the foil body in place with light-proof, black electrical tape and adding a simple, hinged shutter, also made from black tape. Once secured in place, the body produces a pinhole focal length of around 10mm. Angle of view is 94° measured across the diagonal of the 13x17mm (1/2 x 1 1/8in) format. The "mouth" camera has no viewfinder, and its shutter is activated simply by Quinnell opening and closing his mouth, as shown.

index

acknowledgments

Many thanks to all the people who have freely given of their time during the research of this book, and to all the photographers who agreed to be involved. Particular thanks are due to:

Colin Harding at the National Museum of Photography, Film and Television, Bradford
The Science Photo Library, particularly picture researcher Tom Watkins
Philip English for checking copy
Andrew Davidhazy at the Rochester Institute of Technology
Zolt Levay at the Hubble Space Telescope
Ed B. Massey and Joseph B. Gurman at NASA
The Museum of Holography, Chicago
Philips Ultrasound Research
Eddie Ephraums
Justin Quinnell
Minox (Germany)
Royal Geographical Society, London
Gunilla Hedeshund, Abforlag Bonnier, agent for Lennart Nilsson
Michael Pritchard at Christie's. (Contact Christie's, 85 Old Brompton Road, London SW7 3LD, UK. Tel: +44 (0)207752 3279, fax: +44 (0)20 7752 3183 or www.christies.com/cameras.)

Many thanks to the staff at RotoVision for their efforts and team work.

Most of all, thanks to Sarah, Emilia and Charlie for their support as always.